Great
Photography

Great Photography

*by Shawn Frederick
and Bill Gutman*

ALPHA

A member of Penguin Group (USA) Inc.

ALPHA BOOKS

Published by the Penguin Group

Penguin Group (USA) Inc., 375 Hudson Street, New York, New York 10014, U.S.A.

Penguin Group (Canada), 10 Alcorn Avenue, Toronto, Ontario, Canada M4V 3B2 (a division of Pearson Penguin Canada Inc.)

Penguin Books Ltd, 80 Strand, London WC2R 0RL, England

Penguin Ireland, 25 St Stephen's Green, Dublin 2, Ireland (a division of Penguin Books Ltd)

Penguin Group (Australia), 250 Camberwell Road, Camberwell, Victoria 3124, Australia (a division of Pearson Australia Group Pty Ltd)

Penguin Books India Pvt Ltd, 11 Community Centre, Panchsheel Park, New Delhi—110 017, India

Penguin Group (NZ), cnr Airborne and Rosedale Roads, Albany, Auckland 1310, New Zealand (a division of Pearson New Zealand Ltd)

Penguin Books (South Africa) (Pty) Ltd, 24 Sturdee Avenue, Rosebank, Johannesburg 2196, South Africa

Penguin Books Ltd, Registered Offices: 80 Strand, London WC2R 0RL, England

Copyright © 2005 by the Penguin Group (USA) Inc.

THE POCKET IDIOT'S GUIDE TO and Design are registered trademarks of Penguin Group (USA) Inc.

International Standard Book Number: 1-59257-402-5

Library of Congress Catalog Card Number: 2005923955

07 · 06 05 8 7 6 5 4 3 2 1

Interpretation of the printing code: The rightmost number of the first series of numbers is the year of the book's printing; the rightmost number of the second series of numbers is the number of the book's printing. For example, a printing code of 05-1 shows that the first printing occurred in 2005.

Printed in the United States of America

Note: This publication contains the opinions and ideas of its authors. It is intended to provide helpful and informative material on the subject matter covered. It is sold with the understanding that the authors and publisher are not engaged in rendering professional services in the book. If the reader requires personal assistance or advice, a competent professional should be consulted.

The authors and publisher specifically disclaim any responsibility for any liability, loss, or risk, personal or otherwise, which is incurred as a consequence, directly or indirectly, of the use and application of any of the contents of this book.

Most Alpha books are available at special quantity discounts for bulk purchases for sales promotions, premiums, fund-raising, or educational use. Special books, or book excerpts, can also be created to fit specific needs.

For details, write: Special Markets, Alpha Books, 375 Hudson Street, New York, NY 10014.

Photos may not be transferred to other projects/entities without the written approval of Shawn Frederick Photography.

To Anne, with much affection.
—Shawn Frederick

Contents

Introduction

Nearly anyone can grab a camera and take a picture. It's simple. Aim and shoot. But it takes some real knowledge of the craft—and lots of practice—to transform yourself from a person who aims and shoots into someone who can consistently take quality photographs.

To be a better photographer, you have to know about film and lenses, lighting and filters, and the various ways to set your camera and use a flash. You've also got to understand framing and contrast, as well as depth of field. All these elements go into the making of a very competent and reliable photographer who can take fine photos in a number of different conditions.

In this book we will take you on a photographic journey. We begin by describing basic and not-so-basic camera features, as well as the accessories that can often be invaluable. We also discuss the all-important elements of lighting and exposure, which can make or break any photo, and then describe how to compose your shots and frame them correctly. From there, we describe various ways to shoot sports and action, people and portraits, and landscape and scenery. Along the way we provide concrete, practical examples and invaluable advice and tips on how to make any kind of photo better. Finally, we describe the new imaging software that has helped to make digital photography a new and integral part of an age-old industry.

In addition, we've scattered the following boxes throughout the chapters. They aren't required reading, but if you do decide to take a peek, here's what you'll find:

Shutterbug Lingo

Here you'll find definitions of some of the more unusual terms associated with photography that any amateur shutterbug may encounter.

Tricks of the Trade

Look in these boxes for those little extras that can make an average photo a good one and a good image great. You'll find a variety of tips for improving your photography skills.

Out of Focus!

Here you'll find out about possible photography pitfalls and how to avoid them.

Acknowledgments

The authors would like to give thanks to Amy Kwadler of Canon USA for her guidance and for supplying the fine Canon product photos.

Photo Credits

All nonequipment photos courtesy of Shawn Frederick (www.frederickphoto.com). All equipment photos courtesy of Canon USA/Amy Kwadler.

Trademarks

All terms mentioned in this book that are known to be or are suspected of being trademarks or service marks have been appropriately capitalized. Alpha Books and Penguin Group (USA) Inc. cannot attest to the accuracy of this information. Use of a term in this book should not be regarded as affecting the validity of any trademark or service mark.

Getting to Know Your Camera

In This Chapter

- Your camera's basic features
- What all those icons mean
- Loading film and memory cards
- Camera care and maintenance

If you enjoy taking pictures and can do it well, you have the ability to capture a lifetime of memories. Plus, photography is a hobby that you can grow with—there are always new techniques to master, new subjects to photograph, and new equipment and accessories to discover.

In this chapter, we introduce you to the basic cameras, lenses, films, and digital media that we'll be referring to throughout this book. To get started, let's take a look at your camera.

The Basic Features You'll Find on Every Camera

Every camera, no matter how many bells and whistles it has, is essentially a light-tight box that holds your film or digital media and records images by letting a controlled amount of light reach the film (on a traditional camera) or digital card (on a digital camera).

After light penetrates the lens (see Chapter 3 for more on lenses), it enters the camera through the aperture. The aperture is nothing more than a diaphragm that opens and closes when you click the shutter, allowing a specified amount of light to reach the surface of the film and record your photograph.

Your camera's aperture works in tandem with the shutter curtain to properly expose your photograph (see Chapter 5 for more on proper exposure). The shutter curtain is an opaque window that opens and closes at variable speeds to control the amount of time that light is allowed to reach the surface of the film.

Specialized Camera Settings

Here are some other features that appear on many cameras (refer to your camera's manual for an explanation of the features specific to your camera):

- **Adjustable focus settings.** Most point-and-shoot cameras do the focusing for you, so there is no focus mode on them. AF SLR cameras usually offer a variety of focusing modes, including, of course, autofocus (AF) mode. When your camera is set on AF, it focuses on the subject in the viewfinder automatically when you press the shutter button halfway down. When your camera is set on manual focus (MF) mode, you must adjust the focus automatically by turning the lens's focusing ring. Several SLRs offer other, more specialized focusing modes as well.

- **Adjustable zoom settings.** Point-and-shoot cameras with a zoom feature have a telephoto (T) mode, which zooms in on the subject, and a wide-angle (W) mode, which zooms back to let you fit more of a scene in your shot.

- **Adjustable exposure settings.** Although point-and-shoot cameras adjust the aperture and shutter speed automatically, SLR cameras allow you to adjust the settings (refer to your manual) or set the camera on automatic exposure (AE) mode, which sets the exposure for you.

- **Adjustable flash settings.** Among the flash settings you might find on your camera are auto flash mode, in which the camera decides when you need flash and fires it for you; fill flash, in which the camera fires the

flash every time you take a picture; and flash off mode, in which the camera won't fire a flash even if the light meter indicates it's needed. Higher-end cameras also often have a red-eye–reduction mode, which helps to eliminate the red spots that appear all too often in photographs of people.

- **Adjustable metering settings.** SLR cameras offer a variety of modes for their built-in light meters (see Chapter 5 for a discussion of the various modes).

If you have an AF SLR camera, it probably has a lot of features that are beyond the scope of this book. It's essential that you read your camera's manual to learn about the various features and how to use them.

Loading Your Camera

Whether you have a digital camera that takes a memory card or a traditional camera that uses a roll of film, you need to know how to properly load your camera. If you observe a few rules of handling memory cards and film canisters, you'll have absolutely no problem.

Loading Your Memory Card

A memory card is a small, square disk, about an inch and a half long on each side. To load it into your digital camera, you simply slide it into the designated slot on the side or bottom of the camera.

Memory cards come in a variety of file sizes. You can purchase cards from 64 megabytes all the way up to 4 gigabytes, and everywhere in between. The size determines the number of images that you can record before you need to change or erase the card. If you know you will be taking a lot of pictures on a given day, you should either use a larger memory card or carry several smaller ones. Of course, the more memory a card has, the more it will cost.

Loading Your Film

Loading film is a little more involved than loading a memory card, but it's by no means difficult. Film comes in a round, light-tight canister, with a short piece called the leader section protruding from the slot. To load the film, place the canister into the film chamber of the camera. When it's properly installed, the canister will be held in place by a post that secures either the top or bottom of the canister.

Tricks of the Trade

When loading film into your camera, be sure not to touch the shutter curtain inside the camera. It is very sensitive and can easily become damaged or break.

After you've securely inserted the canister in the back of the camera, pull the leader across the

camera body to the take-up spool on the opposite side of the camera, making sure that the sprocket holes along the film's edge are properly aligned withthe advancement sprockets on the take-up spool. Although cameras differ slightly in design, in most cases you simply lay the film on the take-up spool, close the back, and the camera will automatically wind the film into position for the first shot.

Here are some general rules for safe and successful film loading:

- When opening your camera, make sure you're not in a position where any kind of debris, dirt, dust, or sand can enter the camera. Any foreign substance can affect the proper working of the camera mechanisms. Dirt, sand, and dust can also scratch the surface of the film as it advances or rewinds.

- Always load your film in an area away from bright, direct sunlight. If this is impossible, stand with your back to the sun and shade the camera with your body.

- Never unload film or digital media in adverse weather conditions such as snow, rain, or high winds.

Film is available in rolls of 12, 24, or 36 exposures. As with the digital card, the amount of exposures you buy should be determined by the number of photos you plan to take.

Unloading Your Film

When you finish shooting a roll of film, most cameras will automatically rewind the film into the canister so that all you have to do is open the back and remove the canister.

Many cameras also have a manual rewind option. In the event that you haven't shot all the photos on a roll but want to have that film processed immediately, press the rewind button and the film will return to the canister for removal.

The Importance of Care and Maintenance

The proper care and maintenance of your camera is essential. If you don't keep your camera in A-1 working condition, not only can it affect the quality of the photos you take, but you may find yourself making a costly trip to a repair shop. Fortunately, maintaining a camera is not difficult.

Here are a few basic things you should do every time you plan to use your camera:

- **Clean the body of the camera.** Make sure the camera is free of dust and that the lens is clean. The smallest piece of dirt or grit on the lens might show up in a photograph; more importantly, it can put a permanent scratch on the lens.

Use a can of compressed air or a blower bulb (available at any camera supply store) to remove any dust or loose particles from the camera body. Afterwards, wipe the camera down with a soft cloth.

- **Clean the lens.** Begin by blowing it off with compressed air or a blower bulb. Next, apply a lens-cleaning solution to a piece of lens-cleaning cloth (not directly onto the glass). Rub in a circular motion, beginning at the outside of the lens and working to the center. Finally, go over the lens once again with a dry soft cloth.

 Out of Focus!

Be careful if you decide to blow off dust or loose particles on your lens with your own breath. The resulting condensation might cause the particles to adhere more strongly to the lens, so when you wipe the lens with a soft cloth you increase the risk of scratching the coating of the lens.

Once you've finished with the camera for the day, especially if you were shooting outdoors, repeat the preceding steps before putting the camera away. Don't become lazy when it comes to maintaining your camera. Just because you've only used the

camera for a short time doesn't mean you don't have to clean it.

If you're not planning on using your camera for a substantial period of time, say a month or more, you should remove the batteries to avoid the possibility of damaging your camera should the batteries corrode or leak.

When Something Goes Wrong

Today's cameras are designed to be simple and easy to use, and with the proper care they should last for many years. No camera is perfect, however, and if you experience problems you should know what steps to take. If you think something is wrong with your camera, don't play amateur repairman. If you try to fix it yourself, you not only risk causing more damage, but you might also void the manufacturer's warranty.

 Tricks of the Trade

If your automatic camera won't turn on, check the batteries. Make sure they are installed properly and fully charged. If the camera still won't turn on after checking or replacing the batteries, take it to a repair shop.

Have your camera checked by an authorized repair shop if you encounter any of the following problems:

- The shutter release fails to fire properly.
- The lens won't focus.
- The film fails to advance or rewind properly.
- A moving part doesn't seem to be working smoothly.
- You get an error prompt.

In addition, you should also take your camera to a repair facility for a checkup if you drop it on a hard surface or it gets excessively wet (be sure to remove the batteries immediately if the camera gets wet).

With some basic care and maintenance, your camera should give you many years of excellent service.

The Least You Need to Know

- Familiarize yourself with the features and functions on your camera before you begin to use it.
- Loading film or a memory card into your camera is not difficult if you follow a few simple rules.
- Routine cleaning and basic maintenance is an important part of keeping your camera in good working order.
- Never try to play amateur repairman. If something is wrong with the workings of your camera, take it to an authorized dealer.

Choosing the Right Camera for Your Photography Needs

In This Chapter

- Point-and-shoot vs. SLR
- Budget cameras and throwaways
- Film vs. digital

If you already have the camera or cameras you want, then you are ready to go about becoming a better photographer. However, after reading this chapter and learning about various types of cameras, you might decide that it's time to upgrade. Still using a point-and-shoot? You might decide you want the versatility of an SLR. Or, maybe now that you have a computer, you'd prefer to shoot with a digital camera, so that you don't have to buy film and can download, save, print, and e-mail pictures with your computer.

The feature-laden digital and film SLR cameras on the market today accept a variety of accessories and give you options you won't have with a point-and-shoot and certainly not with a basic disposable or throwaway camera. So even if you already have a camera that you like, this chapter will inform you of possible alternatives and options.

Considering Your Photography Goals

Before reading the rest of this chapter, we encourage you to spend some time thinking about the kinds of photos you plan to take. Your answers to these questions will help you decide whether to upgrade or stick with your present camera:

- How often are you planning to use your camera? A few times a year? Several times a month? Only for special occasions?

- What type of photos will you be shooting? Snapshots of your kids? More formal portraits? Landscapes?

- Will you be shooting in a variety of locations and under different kinds of conditions? Do you anticipate shooting in inclement weather, including rainstorms and in dusty/windy situations?

- Do you plan to pursue photography as a serious hobby?

Now that you've spent some time thinking about your goals as a photographer, let's look more closely at the kinds of cameras available, so you can make a more informed decision.

Point-and-Shoot Cameras

A point-and-shoot camera (see Figure 2.1) works just like it sounds. You turn the camera on, point it at your subject, and depress the shutter button. The camera focuses and adjusts the exposure automatically. In other words, it does almost all the work for you. Many point-and-shoot cameras have a manual flash option, though typically the flash will only fire when the lighting calls for it.

It's now also very common for point-and-shoots to have limited zooming capability; although you can't change the lens, this feature enables you to take a wider variety of photographs (see Chapter 3 for more on lenses).

Figure 2.1 *A typical, inexpensive point-and-shoot camera.*

Point-and-shoot cameras are available in both film and digital models.

The Pros

Even serious amateurs will sometimes want to use a point-and-shoot camera. The primary advantage of a point-and-shoot is that you can take it out almost anywhere and begin taking photos immediately. You don't have to check the light conditions, worry about which lens is on the camera, or calculate the proper exposure. Using a point-and-shoot is the quickest way for an amateur photographer to start taking quality pictures. Of course, if you buy an autofocus SLR, you can choose to have it do all of these things for you, too, but you get the added bonus of being able to adjust them automatically as well.

 Out of Focus!

Keep in mind that point-and-shoot cameras are not necessarily cheap cameras. You can buy high-quality point-and-shoot cameras that are still very easy to operate.

Higher-quality (and thus more expensive) point-and-shoot cameras have better quality lenses. They also have features usually associated with the SLR, including the manual flash and limited zooming

capabilities mentioned previously. In addition, some more advanced point-and-shoots have special glass adaptors that screw on and convert the lens so that it acts like a wide-angle or telephoto lens on the SLR (for more on lenses, see Chapter 3).

Higher-end digital point-and-shoots produce images with more *megapixels*, which create a higher-quality photograph. A camera with a 2.0 megapixel rating will not take as sharp of photos as one with a 5.0 megapixel rating (digital cameras are discussed in detail later in this chapter).

 Shutterbug Lingo

A pixel, which is short for picture element, is a tiny, colored square that ultimately forms your digital image. A **megapixel** is a million pixels. If you have a 2.0 megapixel camera, that means it produces images made up of two million pixels. The higher the megapixel rating of the camera, the higher quality each image will be.

The Cons

On the downside, if you find yourself photographing subjects at greater distances, or even if you want quality close-ups, a point-and-shoot might not be the best choice, even with limited zooming capabilities and lens adaptors. There is a trade-off:

You are getting a camera that is extremely easy to use and requires no preparation or extra adjustments, but is sometimes limited in its functions and features and in the types of photos you can capture. If you want the option of shooting a wider variety of photographs, then it's time to start thinking about buying an SLR camera.

Autofocus (AF) Single-Lens Reflex (SLR) Cameras

The term SLR stands for single-lens reflex, which describes a system in which you can look through the viewfinder and, via a combination of a prism and mirror, see directly through the lens (see Figure 2.2). This setup enables you to view the exact image you'll be recording, edge to edge, top to bottom. Many photographers, including amateurs, prefer the SLR system because they feel it gives them the ability to more accurately frame an image. SLRs are available in both film and digital models.

The term AF stands for autofocus, meaning that the camera has a fully automatic mode that determines the appropriate exposure, focus, and flash modes for the scene you are photographing. Using an AF SLR to take a photograph is as easy as using a point-and-shoot, but because of the better features that come with the SLR, you'll get a better picture every time.

Figure 2.2 *A very good, medium-priced AF SLR camera. It has the capacity for changing lenses and adding many accessories.*

With an AF SLR (either 35mm or digital) and a few basic accessories, you can take a much wider variety of photos than with a point-and-shoot. For instance, you have the option of completely changing the lens and either manually setting your aperture and shutter speed or letting the camera determine the exposure for you (see Chapter 5 for more on exposure settings).

Using an SLR with the appropriate lens, you can shoot from much greater distances, snap action photos and actually freeze the action, and ultimately change the effects of the photo you are shooting. In a nutshell, the SLR gives you the option of *creating* an image rather than just *recording* it.

Budget Cameras and Throwaways

You can certainly take photos with low-end budget cameras—those costing $25 or less—and the throwaways we mentioned earlier, but you will be severely limited in what you can do. The functions and features that give you versatility simply aren't there. The only reason to use this kind of equipment would be if you rarely take pictures. Think of them as a one-shot deal for someone who doesn't own a camera but wants to take pictures of a single event or activity.

You might also decide to use a throwaway camera if you want to take snapshots in conditions—such as a canoe trip down a river with some white-water rapids—that might ruin your primary camera. Keep in mind, however, that there's little you can do to make the snapshot special or put your own personal stamp on it.

A throwaway can serve as an emergency camera if you're headed somewhere and have forgotten yours. But there is no way a low-end budget camera or throwaway can come close to taking the place of even the most inexpensive point-and-shoot or SLR. These cameras do not have quality lenses, and they probably will not have features such as a flash unit, red-eye reduction, a self-timer, focus preview option, and a variety of aperture and shutter-control settings. Either one of the latter two cameras would make a better choice if you plan to take photos on a regular basis.

Film vs. Digital

Film has been the cornerstone of photography for more than 100 years, whereas digital imaging has only come to the fore in the last decade. Yet, many people have readily made the switch from film to digital because they prefer the ease and immediacy of digital photography.

Although many professional photos are now re-corded digitally, film still has a place in the world of photography. There are differences between images produced on film and those produced digitally, although with advances in technology, those differences are quickly diminishing. Let's take a closer look at the differences, and what they mean for you.

Here are some of the reasons you might find you prefer shooting your photos with film, though with an extra step or two, you can now do most of the same things with digital imaging:

- Film has a unique visual quality that some see and others don't. If you fall into the former category, then film is for you.

- Some people, particularly those who develop their own film (a technique that is beyond the scope of this book), feel that film puts them in closer touch with the creative process.

Tricks of the Trade _____

If you have several rolls of film and don't plan to use them soon, it's best to store them in a cool, dry place. If you don't have an adequate place for storage, you can put the film in a refrigerator; however, you should never freeze your film.

- With film cameras, after you've finished shooting a roll of film, you can leave the developing and printing up to someone else. All you have to do is drop the film off at a processor and pick up the finished prints later.

Digital photography has made great inroads into the photographic industry over the past 10 years for a very good reason. Many beginning photographers today are computer literate, and they like the idea of using their computer to store, print, edit, and send photos. If you don't have a particular allegiance to film and want to control the processing yourself, then getting a digital camera might be right for you.

With digital photography, you may well look upon the following as a distinct advantage over using film:

- You can see the image on your camera's LCD screen as soon as you snap the shot.

- You can download images from your camera directly into your computer.

- You can use a photography program to enhance and even change your photos. (These programs are discussed in Chapter 12.)

- You have the option of printing your photos on a variety of photographic papers, some of which closely resemble a finished print from film. (Keep in mind that you'll need a high-quality printer if you want your digital prints to be similar in quality to a corresponding photo from film.)

- You can e-mail digital images to friends and family.

- If you fill a media card and want to shoot additional photos, you can review and/or download those you've already taken and erase them, opening up space on the card for more shots.

Tricks of the Trade

You can get prints made from media cards at some one-hour photo centers or the photo counter at some discount stores.

Film versus digital: What it comes down to is really what you prefer. If you haven't worked with either media before, discuss the pros and cons with

some friends who take pictures regularly and see what they think. Of course, if you don't have a computer, you really don't have a choice: It's got to be film. Film might be the old-fashioned way, but it's a tried-and-true part of the photographic craft.

The Least You Need to Know

- Before you choose a camera, you should decide how often you will use it, the type of photos you plan to take, and how much you want to spend.
- A point-and-shoot will make your job easier, but the SLR will enable you to shoot a wider variety of photos.
- Budget cameras or throwaways can't come close to providing as high of quality photos as those produced with point-and-shoot and SLR cameras.
- If you own a computer and quality printer, you might want to choose a digital camera over one that uses film.

Chapter

Choosing Your Lenses and Accessories

In This Chapter

- The importance of the right lens
- How different lenses work
- What filters can do
- Other handy accessories

In this chapter you'll learn about the various lenses and accessories that can enhance your total photographic experience.

Lenses and filters not only enable you to take a wider variety of photos from both greater and shorter distances, they also make it possible to alter, correct, and enhance the existing lighting conditions. Ultimately, they give you more control over your photographs.

Other accessories, such as tripods, cable and remote releases, and lens hoods can add to your

versatility as a photographer and help you to take better pictures.

All of these items—with the exception of tripods—can only be used with an SLR camera, so it's best to leave your point-and-shoot at home if you plan to use them.

What Lenses Do

Generally speaking, a lens is a disk made of ground glass or plastic that bends light. A photographic lens is a plastic or metal barrel with one or more lenses inside of it. The lens gathers light from the scene you are photographing and bends the light so it focuses on the film surface, allowing you to capture an image.

In addition to focusing light onto your camera's film, lenses also control the amount of light that reaches the film via the aperture (which is essentially an adjustable opening within the barrel of the lens) and control the amount of a scene that is included in the frame of your shot based on the focal length of the lens.

Lenses for Every Situation

The type and quality of your lens is one of the most important factors in getting the best possible pictures. A wide variety of interchangeable lenses are available for taking almost any kind of photo you can imagine. You can take the same photo with

two different focal length lenses (i.e., telephoto and normal) and get completely different results.

Tricks of the Trade

When you are shopping for lenses, always pay close attention to the f-stop numbers, which represent the ratio between the diameter of the lens's aperture and its focal length. As a rule of thumb, when comparing two lenses of the same focal length, the lens with the lower maximum f-stop number is the better quality lens. A normal 50mm lens with a maximum f-stop of 2.8 will allow twice the amount of light to reach the film surface than the same size lens with an f-stop of 5.6. (The smaller the f-stop number, the larger the aperture; the larger the f-stop number, the smaller the aperture.) The lens with the lower f-stop will allow you to properly expose the film in lower-light situations.

In addition, always buy the best quality of lens you can afford. A cheaper lens will not give you as sharp an image as a more expensive one. This is because less expensive lenses are usually constructed of lower quality glass and, as a consequence, will not allow as much light to penetrate to the surface of the film. With a better quality lens, you can take photos in a larger variety of lighting conditions.

Point-and-shoot cameras come with a fixed lens.
This is a general-purpose lens that you can use
to shoot a variety of everyday photographs and
get fine results. However, a camera that gives you
the option of changing your lenses (via a mount on
the end of the lens barrel and on the front of the
camera) also gives you the ability to take a much
wider range of photos, such as taking pictures from
great distances or extremely close up. Each differ-
ent lens provides the photographer with the means
of taking a photo in a slightly different way.

If you think you're going to be using your camera
for photographing a wide range of subjects, such
as athletic events, weddings, or even close-ups of
flowers in your garden, then you might be better
off using an SLR camera, which gives you the
option of changing lenses.

Let's take a look at several different types of lenses
and see why each can be valuable to you.

Normal Lenses

When you look through a normal lens you are see-
ing essentially the same viewing perspective that
you would see with the naked eye. Normal lenses
usually range between 35mm and 50mm in focal
length, which is all you need for shooting snap-
shot–style pictures, where your subjects are from 8
to 10 feet away. That doesn't mean that you can't
use this same all-purpose lens to photograph a con-
cert, or take a shot from the top of Grand Canyon.
But shooting these types of photos with a normal

lens will not allow you to zoom in or get any closer than where you stand, so faraway subjects will appear very small in the frame of the picture. To get closer to your subject or to create a wider angle, you must use a different lens.

Telephoto Lenses

A telephoto lens (see Figure 3.1) lets you bring subjects closer to you optically when you cannot get closer to them physically. For instance, if your son or daughter is in a school play and you aren't allowed to photograph from the first row, the tele-photo lens will enable you to shoot *as if* you were in that first row. This means that your subject will fill more of the frame of the picture than if you were using a normal lens from the same distance.

Telephoto lenses are larger than normal—you've probably seen photographers at sporting events using lenses that dwarf the camera and require a tripod to keep them in place.

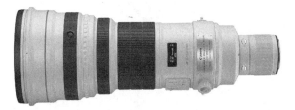

Figure 3.1 *A 200mm telephoto lens. At nearly 12 inches long, it's not easy to hold by hand.*

Typically, telephoto lenses range from 100mm to 300mm in focal length. You would typically use a 100mm focal lens when the subject or subjects are from 15 to 25 feet away and you want to fill your frame and make the subjects appear much closer than they really are. If you're standing on the sidelines at a soccer game or even sitting up in the bleachers and want to photograph some close-up action, you will probably need a 200mm or greater focal length lens.

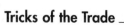

Tricks of the Trade

If you're shooting with a standard telephoto lens and cannot set up a tripod, spread your feet, take a good, sturdy stance, then brace your elbows against your body and breathe normally. In effect, you're acting as a human tripod to keep the camera and lens as steady as possible.

Lenses with focal lengths of 300mm or more are called supertelephoto lenses. These high-powered lenses are typically used to photograph faraway subjects (see Figure 3.2) such as wildlife, where you cannot get close for fear of scaring the animals off (or getting eaten!), or maybe photographing a hot-air balloon during an air show.

Figure 3.2 *This photo was taken from about 75 feet away with a 600mm supertelephoto lens.*

Wide-Angle and Extreme Wide-Angle Lenses

With a wide-angle lens (see Figure 3.3) you can cover a wider perspective in your photographs. Wide-angle lenses are great for shooting large groups of people, such as at a graduation or wedding, or when you want to fit a lot of scenery in a single frame (see Figure 3.4). If you want to take a picture of someone standing between two huge sequoia trees, a normal lens might not allow you to get your subject and both trees within the frame. A wide-angle lens will more than likely enable you to do this. Wide-angle lenses typically have focal lengths ranging from 20mm to 28mm.

Note that wide-angle lenses don't bring a subject closer; instead, they simply widen the perspective of the frame from where you are standing.

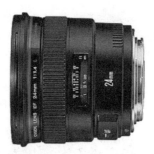

Figure 3.3 *A typical 24mm wide-angle lens.*

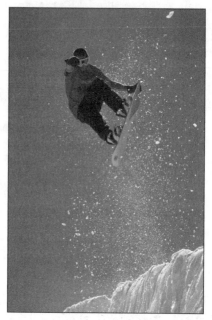

Figure 3.4 *This photo was taken with a 24mm wide-angle lens, which allowed the photographer to show both the subject and his immediate surroundings.*

Extreme wide-angle lenses typically have a focal length of 8mm to 18mm. They are used when you want to capture an even wider perspective in your frame than a wide-angle lens can achieve. For example, if you are photographing a skier or snowboarder coming off a jump, a normal wide-angle lens might only show the jumper and his take-off point. An extreme wide-angle lens will also show where the skier came from and where he will land, all in a single frame.

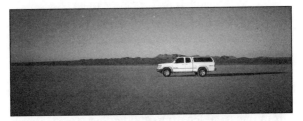

Figure 3.5 *Using an extreme wide-angle lens, the photographer captured much more of the surrounding landscape than he otherwise would have been able to.*

If you're using a wide-angle lens and still find that you cannot fit both your subject and its immediate surroundings in the frame, it might be time to add an extreme wide-angle lens to your bag.

Shutterbug Lingo

Another lens in the extreme wide-angle family is known as the **fish-eye lens**. Fish-eye lenses are usually 15mm or 16mm in focal length and have a field of view that is roughly 240 degrees. This specialty lens gives you the effect of looking into a fishbowl, bending the horizon line in a circular fashion, and giving your photos a different look. For the amateur, this is a lens to simply use for fun.

Zoom Lenses

With a zoom lens (see Figure 3.6) you can adjust from one focal length to another—a process that's often simply called zooming. A wide-angle to normal zoom lens will zoom from a 20mm wide angle to a 35mm normal. Other typical zoom lenses are the normal zoom lens, which extends from 35mm to 80mm, and the telephoto zoom lens, which will go from 80mm to 200mm and sometimes longer.

Zoom lenses are a great utility to have in your camera bag. If you have a versatile zoom lens on hand, you can eliminate the need for additional fixed lenses—one lens can do the job of two or three. Zoom lenses are more expensive than a single fixed lens, but because they will eliminate the need for additional lenses, they can save you money in the long run.

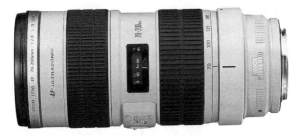

Figure 3.6 *A zoom lens with a range capacity of 70mm to 200mm.*

Tricks of the Trade

The size of lens you use depends on how much of the frame you want your subject to fill and how far away the subject is. For example, if you want just a single subject to fill 75 percent of the frame, at 5 to 7 feet away you should use a 28mm lens. If he is 10 to 15 feet away, you could choose a normal, 50 mm lens. But if he is between 25 and 30 feet away, you might consider using a 200mm lens. And finally, if he is 40 to 50 feet away, you might choose a supertelephoto lens of 400mm or greater.

Filters

Filters are an important part of the total photographic process, though many amateurs find they can manage just fine without them. You can use filters to alter lighting conditions, alter color schemes, and even alter the amount of light that penetrates to the film. In essence, with filters you can alter reality, at least as it's portrayed in your photos. For instance, a filter that enhances color can literally turn a gray sky to blue. Filters give you many options and enable you to put more of an individual stamp on your photographs.

Filters come in a variety of shapes and sizes, and they attach to your camera in different ways. Some simply screw onto the front of the lens, while others drop into a filter holder that attaches to the front of the lens.

In the following sections we'll go over the basic types of filters and suggest when to use them.

Polarizing Filters

Polarizing filters cut down on glare from windows and other glass or shiny surfaces. Use a polarizing filter if you are taking a picture through a window and want to eliminate the glare or reflection from something behind you or on any surfaces that reflect light.

Neutral Density Filters

Neutral density filters cut down the amount of light that is allowed to penetrate the film without affecting the colors in the photo. Use a neutral-density filter when you don't want to change a particular shutter speed or aperture setting, but do want to decrease the amount of light penetrating the film. You might determine certain camera settings are appropriate for the overall photo you want to create, but if you shoot without a filter, the exposure might not be right. Instead of changing the aperture, which will change the overall effect, you can add a neutral-density filter. That way, you can keep the camera setting and get the desired effect, while using the filter to allow the correct amount of light to expose the film.

Enhancement Filters

Various types of enhancement filters can alter the color of an entire frame or part of the frame. In addition, some of these filters can alter the overall look of a photo through special effects. Here are some of the most popular enhancement filters:

- **The color enhancement filter.** A true color-enhancement filter changes the color of the entire frame. If you frame a photo at sunset, but the sky is not as bright and vivid as you would like, a yellow color enhancement filter will make the washed-out color appear more robust.

- **The graduating filter.** A graduating filter comes in a variety of colors and will only change or enhance the color of a specific part of the photograph. Most commonly, it will change only the top half of the photo. You use them when you want to keep the subjects in the lower half of the frame in their natural color, but want to change the color of the top half, such as the sky.

A number of additional enhancement filters can also be used to create special optical effects. Such special filters are not staples of the average photo bag, but if you ever get the yen to experiment or want to create different effects, you can certainly try using any of the following:

- **Star filters** change the appearance of light rays, creating a star-like effect.

- **Centerspot filters** concentrate the focus on the center of the frame while diffusing the edges.

- **Diffusion filters** alter the entire frame so that it has a soft-focus look, making the photograph almost look like a painting.

- **Speed-blur filters** give one part of the frame a motion blur look while the rest remains in sharp focus.

- **Multi-image filters** make a single subject look like several.

- **Mirror-image** or **mirage filters** break a frame in half, showing the subject upright on the top half of the image and upside down on the bottom half.

Out of Focus! _____

It might take some practice to get the desired effect when using a filter. Don't be afraid to experiment. Take a few photos and see just what the filter does.

Color-Correcting Filters

Color-correcting filters alter specific colors within a frame. For instance, if you are photographing a friend on a winter day when the sun is low in the sky, the photo will likely take on the colors of the sun, giving your subject a reddish, warm look. By using a blue color-correcting filter, you can neutralize the warm colors and create a neutral tone in the photo, one that will appear more realistic. The filter accurately corrects the color, giving the subjects a more natural look.

Similarly, shooting in the middle of the day under bright sunlight has a tendency to make subjects look washed out, often giving your photos a bluish cast. To correct for this phenomenon, add a warming filter, probably something in the yellow-to-orange range. This filter will eliminate the bluish

cast and give the photo and subject a more natural look, with perhaps somewhat of a suntanned appearance.

Other Essential and Not-So-Essential Accessories

How many accessories you take along with you on any given day really depends on the type of photographs you're planning to take and how much equipment you're willing to lug around. Hundreds of accessories are available, but you certainly won't need them all. Let's take a look at some of the more useful gadgets.

The Tripod

Most photographers will eventually include a tripod among their accessories. A tripod is like an extra set of hands and legs, all rolled into one. It is a three-legged stand you can mount your camera on so that it remains absolutely stable.

Tripods come in a number of sizes—ranging from a tiny 6-inch tripod, to a full 6-footer, and everything in between. Can't decide which size is right for you? Buy one with adjustable legs so that you can use it at various heights.

Tripods are often used for shooting portraits, but they also come in handy for supporting lenses that are too heavy to hold on your own over a long period of time. They can also be used when you set

your camera in a stationary position and leave
it there for several hours (wildlife photographers
often do this).

Shutterbug Lingo

A **monopod** is literally a one-legged
tripod. It's used to support the camera
when you're working with a telephoto or
supertelephoto lens, yet don't want to be
restricted to a particular spot. With the
monopod, you can move quickly from one
place to another, set it down, and still
have the proper support from which to
work.

Cable and Remote Releases

A cable release enables you to click your shutter
from a tethered cable that is screwed into the
shutter release button, freeing you to view the
scene and take the picture without having to look
through the viewfinder of your camera. It must be
used in tandem with a tripod. This setup can also
be used when taking photos with long exposures,
the reason being once again that you don't move
the camera.

Remote-control shutter releases give you even
more flexibility. Because the shutter is activated
via a radio signal, there is no tether between the

release and the camera. In addition to firing your camera remotely, you can use such devices to fire your flash from afar. These handy devices make it possible for you to become a subject in your own frame, or to stand at a distance from your camera to get the whole perspective of the photo.

You can also use the remote release to take pictures from places you can't safely be. For example, if you want to photograph your son jumping his bicycle, you can place the camera directly under the jump so it will catch him from below as he flies through the air.

Optional Extras

Other optional accessories you might want at some point include the following:

- A camera bag to hold your growing stash of accessories.

- Shoulder or neck straps for carrying your camera.

- A small cleaning kit with some brushes, soft cloths, and cleaning solution for keeping your camera shipshape.

- A lens hood that shades the front of your lens from letting unwanted light from different angles enter into your photo. A variety of lens hoods are available for various types of lenses.

The Least You Need to Know

- Always buy a lens that contains the highest quality glass that you can afford.

- The telephoto lens enables you to photograph subjects from greater distances, whereas the wide-angle lens gives your photos a wider perspective.

- With a versatile zoom lens, you can move from one focal length to another without changing lenses.

- Filters alter light conditions and color schemes, and also change the amount of light that penetrates to the film.

- Accessories such as tripods and cable releases enable you to take a wider variety of photographs.

Chapter 4

Film and Digital Media

In This Chapter

- Making the right film choices
- Types of negative films
- Why you might want to use slides
- Black-and-white films

Films on the market today are more stable in their makeup and render truer and more accurate colors than films from 20 years ago. In addition, a much wider variety of film is available, including films offering a range of color palette options and varying levels of contrast. Whereas in the past, color and contrast effects could only be achieved through a combination of filters and processing techniques, today's films do some of the work for you.

In this chapter, you will learn about the most popular films on the market and how to use them to your best advantage. In addition, we will touch on the use of black-and-white film as well as digital media cards. With so many choices, it's sometimes

hard to decide what kind of film best suits your needs. By clarifying the ways in which these different films can be used we hope to make the choices a bit easier.

Choosing the Right Kind of Film

More than 100 different types of films are available for the 35mm format, but we are only going to discuss the most commonly used varieties. These will enable you to take good-quality photographs in all kinds of conditions. Once you become familiar with the basic films, you can try some of the more specialized films, but it's best to know the basics first.

When deciding what kind of film to use, you must first consider the types of photos you're going to be shooting. Will you be taking pictures indoors or out? Will it be the middle of the day or in the fading light of late afternoon or early evening? Or even possibly at night under artificial light?

 Out of Focus!

Always check the expiration or "develop before" date stamped on the back of the box of film before using it. Colors and exposure might have shifted in outdated film, giving you less-than-ideal results.

Let's start by taking a look at the some of the differences in the various films.

Negatives/Print Films

Color negative film, commonly called color print film, produces color prints. These are the most popular and convenient all-purpose films available. Processing is quick and simple. A one-hour photo service can develop your prints while you have a bite to eat or do some shopping, so you are able to see the results quickly.

Color negative films are reliable, and they are available in a wide range of *ASA numbers*.

Here are the typical characteristics of several different ASA ratings:

- **ASA 100** Most ASA 100 films are extremely sharp when printed and have very fine grain detail to them, which allows a greater degree of clarity to be retained when you enlarge your photos. This is an excellent film to use in general outdoor lighting conditions.

- **ASA 200** The ASA 200 films offer sharpness and grain detail similar to the ASA 100s, but allow you one additional f-stop without having to adjust your aperture for it. (For more on f-stops and aperture settings see Chapter 5.) The sensitivity of the film allows you to shoot in slightly lower lighting conditions.

- **ASA 400** Film with a 400 ASA rating is a moderate, high-speed film that is best used in low-light situations without a flash unit. It will allow faster shutter speeds or smaller aperture settings under normal lighting conditions.

- **ASA 800/1600** These are very high-speed films and will not give you the sharpness and grain detail of an ASA 100. They are intended for use in very low light without the necessity of a flash. They can also be used in situations in which higher shutter speeds are needed to stop or freeze the action.

Shutterbug Lingo

All films are given a sensitivity rating, commonly referred to as the **ASA number.** ASA stands for American Standards Association. The rating number is a mathematical measurement of the film's sensitivity. The lower the rating, the less sensitive the film to light. Conversely, the higher the rating, the more sensitive the film. Ratings range from ASA 50 all the way up to 3200, with many stops in between.

You choose your ASA number based on the kind of lighting conditions you'll be shooting under. If you're taking pictures in bright sunlight in the middle of the day, then you should probably use a film with an ASA rating of 100 or 200. However, if you're shooting in a lower-light situation, then you want to consider using "faster" film, such as an ASA 400 or 800. You'll probably also want to use these faster films if you're shooting at night under the streetlights or the lights along a boardwalk.

Daylight and Indoor Films

The most common films, slide or negative, are blue-light sensitive, daylight films, meaning that they're intended for outdoor use. An indoor, or tungsten film, which is yellow-light sensitive, is a better choice when shooting indoors with lights from lamps or even photo flood lights. Tungsten films are marked with a "T" on the box following the ASA number. Tungsten films, however, are rarely used by amateur photographers.

Slides

Unlike negative film, a slide is a positive image that doesn't have to be printed for you to see a finished product. That's why slides can be shown with projectors that enlarge the image onto a screen or wall via a beam of light.

Slides give you little margin for error in your exposure values. Your exposure has to be perfect or the result will be under- or overexposed. That means you must take great care in coordinating aperture, shutter speed, and any lighting you may add when using slide films. With negative film, you have greater latitude for exposure errors. (The coordination between aperture and shutter speed is discussed in Chapter 5.)

Slide films are available with light sensitivities ranging from ASA 50 to 1000. The characteristics of the various sensitivities are typically the same as those for color negative films (see the previous section). The lower ratings will give you a sharper

image and enable you to enlarge your photographs without losing detail. Higher ASA ratings are used for lower-light situations.

Shutterbug Lingo

Most people simply call a slide a slide. However, if you happen to hear someone mention **transparency film, reversal film,** or **positive film,** don't panic. They're simply using other terms that are used to describe slides. The proper technical term for slide film is reversal film. That simply means that the film is the opposite, or in effect, the reverse of, negative film.

Many advanced amateurs and professionals prefer slide film over negative film for its reproduction qualities in other media, such as magazines, books, posters, and even billboards. It's also easier to store and view slides than negative film that has not yet been made into prints. You can hold a slide page with 20 slides in your hand at one time and view them quickly. If you had 20 prints, you would have to lay them all out or view them one at a time. You also can get prints made from slides.

Out of Focus!

When handling any film, negative, or slide, be careful never to touch the emulsified surface with your fingers; instead, hold it by the edges. And always store exposed film in archival, acid-free pages or files, which are available at any photo supply store.

Black and White Film

Black–and-white film is the traditional cornerstone of photography. It was used in the earliest cameras long before color film was invented. Today black-and-white film is most often used in fine art or gallery photography, photojournalism, or newspaper photography.

Unlike color photography, black-and-white photography lends itself to showcasing the beauty of the grain and contrast. Like color films, black-and-white films are available in a range of ASA ratings, from 100 to 3200. Some illustrate the absolute blacks and whites more, while others emphasize the moderate, or neutral gray, tones.

Don't shy away from shooting in black and white. You can get results quite different from using color. Some photographers think that it's easier to create images with a strong impact using black-and-white film because there is no full color spectrum to

distract from the combination of black, white, and gray tones produced in these photos.

Digital Media

Digital cameras don't use film. Instead, they store information on flash cards, smart cards, memory sticks, SD (secured digital) cards, multimedia cards, or XD picture cards, depending on the type of camera.

Digital cards give you many options you won't find with film. For one thing, you can download the image files onto your computer. In addition, you can reuse image cards, by erasing the images from the card, which frees up space for more images.

On most digital cameras you can set the file or image size, enabling you to take a small-, medium-, or large-size photo. The larger the photo, the more space it will take up on the card. If you choose to shoot with a digital camera, it is in your best interest to buy a media card with the most memory that you can afford.

The Least You Need to Know

- Select your film based on the light conditions and types of photos you'll be taking.
- Always check the expiration or "develop before" date when you purchase film, and always store film in a cool, dry place.

- Consider using black-and-white film when you want to highlight contrasts.
- Rather than film, digital cameras store images on media cards, which can be reused.

Shedding Some Light on Your Subject

In This Chapter

- Using natural light to your advantage
- Adjusting your camera's settings to properly expose your photos
- How to use your light meter
- When to use flash units
- Combining natural and artificial light

The essence of all photography is lighting. Because the success of any given photo depends upon the amount of light entering your camera, it's essential that anyone aspiring to move beyond simple snapshots know how to "read" existing light conditions and alter them accordingly. The word *photography* itself is derived from a Latin word meaning "light writing." That tells you just how important lighting is.

In this chapter, we discuss the factors involved in properly exposing your photographs. We also tell you how to shoot in both natural and artificial light, and how you as the photographer can control the overall look of your photos by controlling the lighting conditions. You will also learn how to combine natural and artificial lighting, when and how to use flash units, as well as how to use both automatic and handheld light meters. It all might sound somewhat complicated at first, but once you learn a few tricks of the trade, deciding upon the correct lighting for your photographs will become second nature.

Remember, if you have an SLR with an automatic settings feature (an AF SLR camera), you can let the camera figure out the proper exposure settings, or you can turn the automatic feature off and expose the film manually. With a point-and-shoot, the camera will always determine the proper exposure settings for you.

Adjusting Your Settings for the Right Exposure

Film is exposed as soon as light reaches it. In order to get a good photograph, the right amount of light must reach the film (controlled by the aperture) for a specific amount of time (controlled by the shutter speed). You can adjust the aperture and

shutter speed on your camera to regulate how much light reaches your film for how long.

The aperture can be adjusted from a small pinpoint to nearly the circumference of the lens. Lens apertures are expressed as f-stops: f/2.8, f/4, f/5.6, and so on. The higher the number, the smaller the opening. When the aperture is adjusted from one setting to the next higher number (from f/5.6 to f/8, for example), the amount of light transmitted through the lens is cut in half.

The shutter curtain contained within the camera opens for varying lengths of time, adjusted by your shutter speed control. It can open for as slow as a minute or longer, or as fast as $\frac{1}{8000}$th of a second. When shutter speed is adjusted from one setting to the next higher number (from 125 to 250, for example, which represent fractions of a second and can be expressed as $\frac{1}{125}$ and $\frac{1}{250}$), the amount of light transmitted through the lens is cut in half.

Note that in the preceding examples, a single adjustment of either aperture or shutter speed has an equal effect on the exposure. So, if you adjust the shutter speed by one step, such as from 250 to 125 you will retain the same exposure if you adjust the aperture a full step, say from f/5.6 to f/8. The combination of the f-stop and shutter speed working in tandem is what ultimately gives you your exposure.

By using a built-in or handheld light meter (discussed later in this chapter), you'll know just where

to set your aperture and shutter speed. By adjusting the aperture, you not only let more or less light in, but also control the depth of field, or depth of focus in your image. While certain combinations of aperture and shutter settings will give you the same exposure, the resulting image will vary in terms of focus.

Suppose the proper exposure for a photograph is to have your aperture at f/8.0 and your shutter at $\frac{1}{125}$th of a second in the midday sun. In theory, if you open your aperture three full stops to f/2.8, and increase your shutter speed by three speeds on the dial to $\frac{1}{1000}$th of a second, you have the same exposure that you had at f/8.0 and $\frac{1}{125}$th of a second.

However, you have substantially changed the overall picture. By opening your aperture to its maximum setting, you have decreased your depth of field. The person you originally focused on will still be in focus, but the area 3 or 4 feet behind him will be completely out of focus.

Going the other way from the original setting, if you stop down the aperture three full stops to f/22.0 and you slow the shutter speed to $\frac{1}{15}$th of a second, you again have the same exposure. This time, however, you have increased your depth of focus and have slowed your shutter speed to the point where if the people in the frame move slightly, they will become blurred.

Tricks of the Trade

If you have a proper exposure setting but feel you want your photo to be lighter or darker, you can achieve this effect by making a slight adjustment to your aperture or shutter. For example, if you want a darker image, you can close the aperture in either third- or half-stop increments, or open the shutter in the same fashion. If you want a lighter image, you move the settings the opposite way. If you shoot a series of photos with the same frame, and each has a slightly different setting, the result is called exposure bracketing.

Light Meters

Light meters are among the most important tools for ensuring that your photos are properly exposed. Photographers use light meters to read the amount of light in the different areas of the frame. The meter "reads" both the brighter and darker areas of the frame and calculates an equation that allows for the correct aperture and shutter speed adjustments for a properly exposed photograph.

Two types of light meters are on the market. One is built into the camera and works in conjunction with the camera's settings. The other is a separate

piece of equipment that you hold in your hand and can move around to the various areas of your frame. You then manually record the light readings from each area and make the adjustments on your camera accordingly.

The Built-In Light Meter

Built-in light meters usually have multiple settings. The most common of these are the spot meter, which allows you to meter different spots within the frame; the centerweight meter, which meters a moderately larger area of the frame; and the overall meter, which meters everything within the frame. Here's how to use each one:

- **The spot meter**—This meter reads specific positions in the frame. When you set your camera to spot metering mode, you will normally see a small dot when you look through your viewfinder. The camera only meters the area covered by the dot. Depress the shutter button only slightly without snapping a picture, and you'll see the aperture/shutter speed readings inside your viewfinder. As you move that spot around the composition of your frame, it will give you light readings for each particular area within that photograph.

- **The centerweight meter**—This setting reads a larger area of the frame. When you set your camera to centerweight metering mode, the meter reads the lighting within

the larger circle in the viewfinder. Use this feature when you want to make sure the center of the frame is properly exposed.

- **The overall meter**—The overall meter reads the lighting in the entire frame, top to bottom and side to side. As with the other two settings, you will see your readings as a small LCD display near your viewfinder. Use this setting to read the entire frame at one time.

Understanding Light Meter Readings

If you are shooting in the spot metering mode and take several readings of the light and darker areas of your frame, you'll notice the readings in the light areas will be much higher than in darker areas. For example, if you're shooting a tight portrait of a person outdoors, head and shoulders only, and the sun is coming from the right, the right side of the frame will be much brighter than the left. If the reading on the right or bright side of the frame is f/11.0 and the reading on the darker side is f/5.6, then you have a two-stop difference between the highlights and shadows. In this sort of lighting situation, a good overall exposure would be to split the difference and shoot the photo at f/8.0.

When using centerweight metering, the metered area might cover both the high and lower light areas described in the previous example. The meter will average these two readings and recommend an

exposure of f/8.0. Keep in mind, however, that the centerweight will not meter the area outside that circle. So although the center of the photo will be properly exposed, the area outside of the center circle might be much brighter or much darker.

To put the rest of the frame into the equation and make sure it's properly exposed, you would use the overall meter.

Tricks of the Trade

You may find that you cannot handhold the camera steady enough at slow shutter speeds. If this is the case, you can use flash, which will enable you to use a faster shutter speed and thus handhold the camera.

Using the light metering features will help you learn about the proper aperture and shutter speed settings for various lighting conditions.

The Handheld Light Meter

Handheld light meters function the same as their built-in counterparts—they read the lighting conditions of a particular area and display the appropriate aperture and shutter speed settings on an LCD screen. However, with handheld meters you must physically read every portion of the frame by

taking the readings close up to your subject. In that respect, they more closely resemble the spot meter function on built-in meters. (When the light is the same for the entire area within the frame, you can take an overall reading of the ambient light in the frame by simply holding the meter in front of you and taking a reading.) Like built-in meters, hand-held meters have an LCD display that indicates the appropriate aperture and shutter speed settings based on the lighting conditions.

Shutterbug Lingo

Flash meters and color meters are specialized light meters. Flash meters give you a combination of readings for both natural light and flash. Color meters read the temperature of colors, not light, and are mainly used by professional photographers.

Natural Light

Natural lighting is light from the sun—and that includes moonlight, which is simply sunlight reflected off the moon at night. Even though it all comes from the same source, not all natural lighting conditions are the same. A bright sun on a crystal-clear day may offer beautiful lighting from which you can attain vivid and colorful

photographs of a sporting event. That same bright radiant sun might be very unflattering when shooting a portrait of a person, because the direction of the light may create unwanted and harsh shadows.

However, when that same sunlight is diffused by a blanket of clouds, it creates smoother lighting and softer shadows, conditions that are perfect for shooting beautiful portraits. Shooting with a complete cloud cover, on the other hand, won't give you those same vivid colors at the sporting event. That's why it's so important to know how a variety of natural light conditions will affect your photographs.

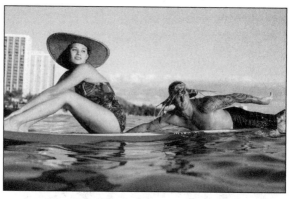

Figure 5.1 *The natural light of the sun creates both texture and depth in this photo, taken at Waikiki Beach in Hawaii.*

To really understand how light affects your photos, you need to get out there and start taking pictures.

Begin by taking photos in a variety of natural lighting conditions, from bright sun to a gray overcast sky, and maybe even at twilight. Looking carefully at the results of your photos in these different natural conditions is step one toward understanding what, if any, corrections you need to make in the future. If, for instance, the shadow areas of your photos are too dark, you'll know that the next time you'll need to add more light when shooting in those same conditions. But there isn't any single "right" way to shoot a photo. As you continue to take photographs, perhaps you'll find that you like some shadow detail or a degree of darkness in certain areas of the photo.

Tricks of the Trade

Many amateur photographers think that the only way to shoot on a sunny day is to have the sun over their shoulder behind them, to avoid all shadows. Such a setup is fine for some applications, but shadow (or the detail of shadow) can give your photos added dimension. You can also change the overall look of your photo by moving either yourself or your subject to relocate the direction of the light and, in effect, change the feel of the photo as well.

Making the Sun Work For You

You can take a variety of steps to control the quality and texture of your photos when shooting on a bright, sunny day. Here are just a couple of adjustments you can make with both the subject and the light to change the overall look of the image:

- To eliminate unwanted facial shadows when shooting a portrait in full sun, place the subject with his back directly to the sun. This places your subject's face in a shadow. When you adjust your exposure to properly illuminate the face, the result will be a softer, shadowless portrait. At the same time, you've also created the additional dimension of depth by using the sun as a backlight.

- Redirect the angle of light. Suppose you are shooting a portrait at midday and the sun is at your subject's left or right, not directly in his face. This angle will create harsh, lateral shadows. You can soften these angular shadows by bouncing light into them. To do this without additional photographic gear, place your subject next to a white wall or building just slightly out of the frame. The white surface will redirect the path of the light and soften the shadows. Again, set your exposure to properly illuminate the face.

● If you're taking pictures outdoors on a dark
and overcast day, you can easily compensate
for the dimmer light by adjusting your shut-
ter speed to increase the amount of time the
light falls on the film (don't forget to adjust
your aperture accordingly). In effect, you're
making a cloudy day brighter.

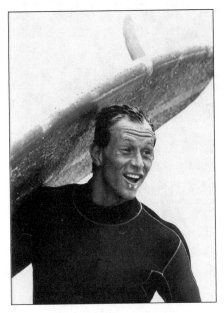

Figure 5.2 *The photographer used the bright
light of the sun to highlight both the surf-
board and the top of the subject's head,
thereby allowing the shadows below to create
depth in the subject's face.*

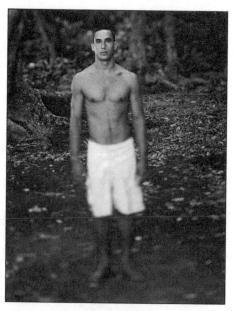

Figure 5.3 *In this photo, the photographer used the sun to illuminate the subject while allowing the dark shadows in the background to show contrast and depth.*

Tricks of the Trade

If you know you'll be shooting on a very cloudy day, you can load a roll of ASA 800 film instead of the ASA 100 or 200 that you would use on brighter days. That way, the film is helping you compensate for the lower lighting conditions.

Artificial Light

Artificial light comes in many different forms. It can come from the bulb of a household lamp in your living room, a streetlight burning on your block, the glare of automobile headlights, or fireworks going off in the sky. Other sources of artificial light include a flash unit attached to your camera, a floodlight illuminating your backyard, or a fluorescent light in your garage. Any source of light not produced by the sun comes under the heading of artificial.

The difference between all these forms of artificial lighting is basically the color temperature that the lights emit. Different color temperatures produce different tones in your photos. For example, when you take a photograph with an incandescent streetlight as your source of illumination, the photo takes on an orange hue. But when you shoot a photo under a fluorescent light, the picture will take on a bluish/green cast. If you don't like a particular tone resulting from an artificial light source, you can manipulate it by using filters or different types of film.

If you're shooting under a fluorescent light, for example, you can use a fluorescent-light color-correcting filter, which will give your subject a natural skin tone and the correct color palette. When shooting indoors with lamp lighting, you may want to use a tungsten film. This type of film will correct the yellowish color shift from the lamplight, giving you the proper color exposure.

Flash Units

Many cameras come with built-in flash units. The job of the flash is to add either a primary source of light for both subject and background, or to apply enough light to act as a filler to brighten the foreground or enhance the lighting of the subject. With today's automatic cameras, both point-and-shoot and SLR, the camera will dictate whether or not the flash unit should fire to illuminate the photo. With such cameras, your job is simply to compose and shoot the photograph. If your flash doesn't fire, that means the exposure is fine without it.

Figure 5.4 *One style of flash unit mounts on the "hot shoe" of a 35mm SLR camera. This unit has both a swivel and tilt feature.*

If your camera doesn't come with a built-in flash unit, you can use a dedicated flash unit. These units normally slide right onto the "hot shoe" on top of the camera's viewfinder and can be made to coordinate with the camera so that the camera dictates if the flash needs to be fired (see Figure 5.4). You simply set the flash to the automatic mode.

On SLR cameras, you can set your flash to fire manually, meaning that it's up to you to decide how much—if any—light the flash unit emits when fired. If you decide you want to control your flash unit manually, experiment with the various settings so you know how much light each setting will produce.

Tricks of the Trade

Tired of taking photos in which your subjects have evil-looking red eyes? Red eye is the result of the flash firing directly into the eyes of the subject. To get rid of the red eye, you must redirect the path of your light, either by bouncing it off the wall or ceiling or using a remote flash at an angle to your subject. Some higher-end SLR cameras have a red-eye reduction feature built in.

Remote Flash

As noted previously, flash is useful for adding primary or fill lighting. But you can create a variety of other lighting conditions by either removing the main flash unit from your camera and placing it elsewhere to illuminate the frame, or using a second, separate flash. To have the second unit fire simultaneously with the flash on your camera, you would use a sync cord or remote control radio slave unit. A sync cord runs from the camera to the remote flash so it will fire as you press the shutter. The remote control radio slave unit is a wireless transmitter that will also fire the flash when you click the shutter. In essence, it's a wireless sync cord.

Tricks of the Trade

Some remote flash units come with a small plastic stand that's about 6 inches high. You can mount your flash on the stand and place it in a variety of different positions, thereby producing a number of lighting effects. If your remote flash didn't come with a stand, you can buy one at any camera-supply store.

Here are some specific effects you can get by placing a remote flash in a strategic location:

- **Backlighting** Use this technique to create light in the background of the photo, which adds depth. The flash can be placed either behind or to the side of the subject and can be directed either toward the back of the subject or away from it, giving two distinctly different effects.

- **Spotlighting** Spotlighting is a direct beam of light accentuating a portion of the frame; it is not meant to be a broad, sweeping source of light. To achieve this effect, position the remote flash so that it is pointed directly at the area you want to light.

- **Rim or halo lighting** If you're shooting a subject with dark hair in front of a dark background, you can use rim or halo lighting to separate the hair from the background. To do this, set up your remote flash directly behind or above and behind your subject at an angle. The flash will then highlight the hair, giving it the desired contrast from the background.

- **Bounce lighting** With bounce lighting, you aim the flash at either the ceiling or wall to flood the scene with an overall blanket of light. This lights the entire photo and gives the photo a softer look. You can create bounce lighting only if you have a mounted flash unit that can be aimed upwards or to the left or right.

You can properly illuminate your shots with remote-flash even if you're using a basic point-and-shoot camera with a built-in flash unit. Let's say you decide to take a family portrait in your living room. Once you set up the shot, you realize the background of your photo may be too dark for the effect you want. All you need to do is set up a remote flash behind the subjects and facing away from them so it will light the back wall or background. When you snap the shutter, both flashes will fire; the one on your camera will light your subjects properly, and the remote flash will give the photo depth by highlighting the background.

Like all other facets of photography, there is no single right or wrong way to use your flash unit. Don't be afraid to try taking pictures of the same scene using different lighting techniques, and compare the results to see which you prefer.

Combining Natural and Artificial Light

By using natural and artificial light sources in concert with each other, you can really take some outstanding and creative photos. The trick is blending the two light sources, and perhaps adding a third source of light with your flash.

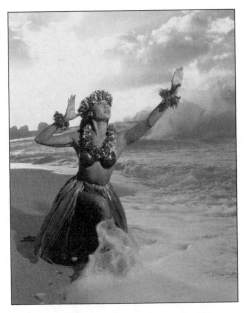

Figure 5.5 *This photo of a hula dancer was taken on the beach at sunset. A flash was used to highlight the subject, while the setting sun served to illuminate the background.*

Let's say that you and your family are standing around a bonfire at sunset. You want to shoot a photo of the kids, whose faces are partially illuminated by the light of the fire. In the background, you can see the warm colors of the setting sun. Although the sun is too dim to be the direct or primary source of light, it is still adding color and light from a natural source. The light from the bonfire becomes your main light to illuminate

your subjects. Voilà—you're combining natural and artificial lighting.

To successfully shoot this scene, you need to compensate for an overall low-light situation. You will need to use a fast ASA speed film, such as an 800 or even 1000. If you only have a slower film, such as ASA 100, then you may want to use a tripod and adjust your aperture and shutter speeds accordingly for a longer exposure.

The most important thing to remember when shooting with both natural and artificial light is to keep both light sources in balance.

Here are some other tips about using natural and artificial light and in conditions that aren't always optimal:

- If one source of light is brighter than the other, you might have to compensate by using a flash to increase the exposure on the dimmer light.

- You might need to use color-correcting filters to alter or neutralize unwanted color shifts caused by one of the two primary light sources.

- SLRs are often a better choice than point-and-shoots in combination lighting conditions for the simple reason that you can control the exposure settings.

Out of Focus! _____

Don't dismiss certain lighting combinations because they aren't perfect for a photo. The varying lights from two different sources can often produce interesting looks that make for a creative image.

The Least You Need to Know

- Proper lighting is the essence of all photography.

- The combination of the f-stop and shutter speed working in tandem is what ultimately gives you your exposure.

- Flash units can be built in to your camera, manually attached to your camera, or set up in remote locations away from the camera.

- Light meters help you properly expose your photographs by "reading" the light within the frame and recommending exposure settings based on those readings.

Composing Part 1: Framing Your Shots

In This Chapter

- Learning to "see" the image in your mind's eye
- Setting up for your shot
- Making your vision come alive
- The final step: clicking the shutter

A little planning and vision on your part can go a long way in making even the simplest of photos better. Before you ever click the shutter release to take a photograph, you should be able to "see" the picture in your mind.

Basic composition involves the way you set up and prepare for the final image you want to capture on film. Whether you're creating a tight portrait or a wide-angle landscape, the basic composition of the shot will be the way the story you want to tell is ultimately recorded by your camera. A poorly composed photo will not strike you or anyone else in

the same manner as a well-composed one. That's why, in the hands of professionals, photography is an art. Your photos may not ultimately be displayed in a gallery, but there is no reason why you can't learn to compose photos that have real visual impact.

In this chapter and Chapter 7, you'll learn how to envision your photograph before you actually set up and shoot. You must consider all the important elements of photography—lighting, type of film, your camera, lenses, flash, and filters. That doesn't mean every photo will be a work of art or has to involve a lot of effort, but by thinking about all these elements, you can rely a little less on luck for getting good pictures and a little more on skill.

Training Yourself to "See" the Image

Anyone can take a roll full of snapshots, but it takes planning and vision to create even a single photograph that captures your subject in a special way so that it literally jumps out at you and elicits a "wow" response from everyone who sees it.

The environment surrounding the subject should not only add balance to the photo, but also portray the subject in the best possible manner. A portrait of a beautiful woman dressed in an evening gown would be completely ruined if she were standing in front of a dirty automobile. Replace the car with a trellis entwined in red roses, however, and you've got a cohesive, beautiful image with a lot of visual impact.

Part of the process of "seeing" your photo involves knowing how to use your equipment to its best advantage. You've got to have the right film for the job and, if you have an SLR, you should have the best lens for the photo you want to shoot. That doesn't mean you can't take excellent photos with point-and-shoot cameras. But you must still have a vision.

Most famous photographs were not taken by chance. The people standing behind their cameras put a lot of thought into their pictures. A photo of Abraham Lincoln, taken by noted Civil War photographer Matthew Brady with the archaic equipment of the nineteenth century, still required the vision of the photographer to make it work. To take consistently good photographs, you must start envisioning them before shooting.

Three Steps to Seeing Your Photo Before You Shoot

Here are a few steps you can take to better learn how to see your picture before you shoot:

1. It all begins with lighting. Consider the lighting conditions and decide whether they are right for both your vision and the photo. Ask yourself the following questions:

 - Do you have the appropriate film? (See Chapter 4 for a discussion of what films to use in various conditions.)

- If it's a sunny day, where will the shadows fall and how strong will they be?

- Are any bright shafts of light penetrating the scene? Will they add to, or detract from, the photo? Be sure to shoot from the angle that will best accentuate the lighting.

- Do you need to change or add to the natural lighting by using a filter (Chapter 3) or flash (see Chapter 5)?

 Tricks of the Trade _____

Remember, when you first look through the camera, you're also looking through whatever lens is attached. Different lenses create different effects, and if the view through the camera isn't what you see in your mind's eye, you might want to change the lens. With point-and-shoot cameras, where you cannot change the lens, it's often more a matter of moving yourself to a different position to get the desired effect.

2. Observe the surroundings closely with your naked eye. Imagine placing an empty frame around the scene—where do you want the edges of the frame to be? Do you need to change lenses to achieve the desired effect?

Determining the frame of your photo will help you to choose the right kind of equipment. For instance, if you have a telephoto or zoom lens, you won't have to get as close to your subject for the composition you want.

3. Finally, think about the story you want to tell. This will help determine where your main subject should be positioned within the frame, and how much background or *negative space* should be included.

 Shutterbug Lingo

Negative space refers to open space within a frame. An empty sky above a head-and-shoulders portrait of a person represents negative space. So does the ocean in the background if you're photographing a child on the beach building sand castles. Photographers use negative or open space to add to the overall effect of a photo.

Once everything seems right, take the picture.

Example #1: Taking a Picture of an Old Man

Let's apply these steps to a photography situation. Suppose you're with your spouse and kids at the park, and you've got your camera out to take some

pictures of your family playing. You notice a very old man walking unsteadily toward you. He's using a cane, and he seems to be unsure of his footing. You decide to photograph him. If you take a tightly composed picture of the old man—one in which none of the surroundings are visible—you've simply taken a picture of an old man with a cane. But if you have a vision, you can do so much more. Let's take this in steps:

Step 1: Check the lighting conditions. Because this is a nearly spontaneous shot, you have to work with what you have. You probably won't have time to choose filters or use a flash. Check your exposure values through the automatic feature in the camera.

Step 2: Next, survey the lay of the land. Look at where your subject is walking, both where he is coming from and the direction in which he is going. Are any children playing ball nearby? Are there other people on the walkway around him, or does something else in the surroundings catch your eye?

Step 3. Tell a story about the old man. If you compose a photograph that encompasses the surroundings as well as the old man, you're telling a much more complete story then you would if you simply photographed the old man. By including three or four children playing in the background, for instance, the photograph will accentuate the man's age. If you compose the photograph so there are several other adults in the frame walking past the

old man, the photo will convey how difficult it is for him to get around with his cane.

Out of Focus!

When deciding where to place your subject in the frame, be careful with extreme close-up portraits. If your subject is too close to the camera, you can get a distorted prospective, sometimes called a "dog-nose" effect. The last thing you want is to make your subject's nose to appear 4 inches long!

By adding these story elements to your photo, your picture will convey more meaning to the reader. You'll be creating an image based on a vision.

Example 2: Taking a Picture of a Tree House

Here's a second example. You build a tree house in the backyard for your kids to play in. You want to take a photo to send to out-of-state family members. If you just grab your camera and use a telephoto lens to fill the frame with the tree house and perhaps your kids looking out a window, you have lost an opportunity to tell a more complete story and take a photo that has real impact. Here's another way to do it:

Step 1: Consider the lighting. For instance, if it's a bright sunny day, check where the shadows fall so you can make sure key areas of your photo are illuminated, leaving less important parts of the scene in shadows.

Step 2: Survey the scene. With a normal or wide-angle lens, you can shoot the scene from far enough away to frame not only the tree house, but the tree itself and part of your yard. You can also show the height of the tree house and maybe have one of your kids in the window, and another at ground level just starting to climb the ladder.

Step 3: Tell a story. You want to create an image that will tell viewers how important the tree house is to your kids and how it fits into your yard. This kind of photo brings the entire scene to life. The photo evokes images of kids playing in the tree house, climbing up and down the ladder, and totally enjoying their backyard environment. By comparison, a close-up shot of only the tree house is a much more stagnant image.

Moving Your Subject or Yourself

If you've walked through all the steps and the shot doesn't seem complete to you, you can still shoot the frame, then make some adjustments and re-shoot the scene. Sometimes, all it takes to improve the shot is to move your subject or move yourself. Let's see how that can work.

If some of the elements in your setup don't seem
right, such as the way light falls on the subject,
or where the shadows are, you can often correct
this by moving the subject within the frame. You
can reposition the subject closer to the camera,
farther from the camera, or to either side within
the frame. If you can't move your subject, you
can move yourself to a different spot with similar
results. Relocating the subject or the photographer
often solves a lighting problem by creating a differ-
ent pattern of shadow and creating more or less
space in the frame around your subject.

 Out of Focus! _____

> If you decide to move your subject or
> even yourself, especially forward or back-
> ward, you might be changing your plane
> of focus. Be sure to recheck your focus
> before shooting and make the necessary
> adjustments.

If all the elements seem right, but you want to
include more of the surroundings in the frame, you
can hold your position and switch to a wider-angle
lens, which won't change the lighting or the posi-
tioning of the subjects, but will simply add more
elements to the frame.

Another way to change the look or effect of your photo is to move up or down. If you shoot from a standing position while photographing an automobile head on, you'd get one perspective—the grill, the hood, and the outline of the roof. If you take the same shot while lying on the ground in front of the car and shooting at an upward angle, the result will be quite different, making that car appear more aggressive, almost as if it's going to run over the top of you. In addition, you're now photographing different parts of the car. If you stand on a ladder and shoot downward, you'll create the effect of the car passing underneath you and, once again, capture different parts of the car in your photo.

Tricks of the Trade

If you are taking pictures of small children or family pets, try getting down to their level and shooting straight ahead. This creates an entirely different effect than standing above them and taking the picture.

If you have the time, try taking the same shot from various angles and then compare the results. You'll probably like one better than the others, and you'll also see how shooting from the different angles changes the way the subject is perceived.

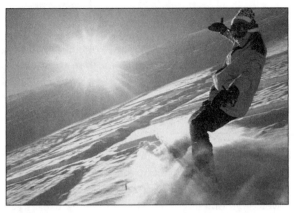

Figure 6.1 *By keeping the subject to one side of the frame, the photographer captured the rays of the sun coming over the rim of the mountain.*

Shooting on the Spur of the Moment

Sometimes you have to take the photo quickly or you will lose the chance forever. In order to capture the moment, you'll have very little time to compose a frame and position your subjects or yourself for the best shot. The following advice will help you make the most out of such situations.

Planning for Spontaneity

You can often do some advance work to prepare for spontaneous moments. If you are at a soccer game, for instance, arrive early and observe the entire layout of the field before the game starts.

Note the angle of the sun, consider where the most concentrated action is likely to be, and pay attention to various background possibilities. Based on these considerations, find a location from which to take your photographs.

After you've found a good spot, make all the adjustments to your camera settings for the proper exposure (see Chapter 5). Now all that's left to do is wait for the "spontaneous" moment to arrive. If the action is approaching from down the field, you can watch it through your viewfinder. Then, whenever the moment comes, your camera is already set and all you have to do is click the shutter.

Using the Automatic Exposure Setting for *Truly* Spontaneous Moments

Sometimes advance preparation is out of the question. If you're in the backyard when your child begins playing with the family dog and your camera is on a nearby table, you might not have any time to frame the scene or set the exposure. In that situation, just turn your camera to the automatic settings feature, and click away. Fortunately, with today's automatic cameras, you should get a properly exposed image.

The more photographs you take under a variety of conditions, the more prepared you'll be to snap them on the spur of the moment. You'll soon find that instinct takes over and you'll automatically find the right position quickly and be able to shoot more spontaneous photos successfully.

The Least You Need to Know

- Learn to think like a photographer and see the image in your mind's eye before you even look through the camera.

- Always consider the overall frame of your photo and where you want to position your subject.

- Use your vision as a photographer to create a total picture that tells a complete story.

- Don't hesitate to move your subject around in the frame or to move yourself to a different position in order to get the best shot.

- When shooting spontaneously, remember to set your camera to the automatic settings feature.

Composing Part 2: Contrast, Depth, and Depth of Field

In This Chapter

- The importance of composition
- Why you need contrast
- Working with depth of field
- Filling the frame and using negative space

In Chapter 6 you learned important steps for framing and shooting your photos to their best advantage. In this chapter, we continue our discussion of the key elements of composition. After you frame your photo you still have to consider contrast, which assists in creating the illusion of depth, as well as depth of field.

Contrast

Contrast is simply the play of highlights and shadows off one another, and it is the element that ultimately separates your subject from its

surroundings. By using contrast in your photos, you can create separation, depth, and impact.

You can vary the contrast to achieve different effects. For example, an extreme high-contrast black-and-white photograph would contain very deep blacks and very radiant whites, such as if you shot someone wearing all black in front of a white wall. A lower contrast black-and-white photo might have more of a neutral, gray tone, in which the highlights and shadows would not be nearly as prominent.

With color, if you shoot a red car up against a red background you're going to end up with a low-contrast image because you have no opposing colors. On the other hand, if you park that same red car in front of a white fence, your photo will have more contrast. If you photograph a blue kite up against a deep-blue sky you might not see the kite at all because of the lack of contrast. But a red or orange kite in that same sky will create a vivid contrast. Beginning to get the picture?

Here's another example:

Suppose a friend who has blond hair and is wearing a white blouse asks you to take a picture of her. She is standing outside against the white siding of your house and says, "Go ahead and snap it." If you do what she says, neither of you will be very happy with the result, because there will be

virtually no separation between the subject's light-colored hair and shirt and the white background of the house.

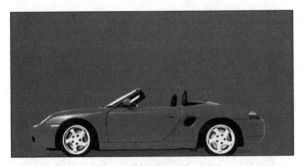

Figure 7.1 *This photo was shot with a monochromatic (one-color) tonal background. Although it is a low-contrast photo, the simplicity of it shows the car in an effective way. Had the same auto been shot in a high-contrast setting, as with a pure white background, the end result may not necessarily have been more striking, but it certainly would have been different.*

To get more contrast, you should have her stand in front of a darker background, preferably one with more visual appeal. For instance, you might ask her to stand near some trees or in front of a dark fence. That way, you will not only create additional contrast, but will take a more interesting photo. See how the hair of the blonde model in Figure 7.2 blends into the light background, whereas the brunette model's hair stands out against the background?

Figure 7.2 *Notice the lack of contrast between the hair and background of model on the right.*

Here are a few things to look for if you want to create real contrast:

- Make sure you have opposing highlights and shadows, either created by the sun or by a noticeable difference between subject and background.

- Choose a background that is lighter than a darker subject or darker than a lighter subject.

- Don't be afraid to move your subject to several different locations to see which gives you the kind of contrast that will help create the best photo.

Tricks of the Trade

Another way to create contrast is to adjust your aperture and shutter settings so that you have a darker exposure. Then add light by using a flash, which will highlight the subject and create contrast against the darker background.

Creating the Illusion of Depth

Depth is a by-product of contrast. Contrast gives you separation between the foreground and background, creating the illusion of a third dimension, or depth.

Out of Focus!

Don't confuse the illusion of depth with depth of field, which is your plane of focus.

A photo in its raw form is two-dimensional, showing height and width. It's up to you as the photographer to create that third dimension, the illusion of depth. (In reality, no photograph is going to be fully three-dimensional. However, by paying close attention to contrasts in your photos, the viewer will get a sense of the depth that you saw through your viewfinder.)

You can create depth in any of the following ways:

- **Contrasting colors and/or shadows.** A red apple photographed in front of a bunch of yellow bananas creates the illusion of depth through the contrasting colors. Two red objects would blend into one another, resulting in a flattening effect.

- **Contrasting the subject and the background.** A blond-haired girl photographed against a black background also creates depth through contrast. A light or white background would almost hide her blond hair and cause the photo to become flat through the lack of contrast.

- **Contrasting highlights and shadows.** Here depth is created by playing light and dark areas off of one another. A photo of the corner of a large building is more effective when one side of the photo is brightly lit and the other side is in shadow. The shadows will create the illusion of depth.

- **Adjusting your field of focus.** When you focus on a person or object in the foreground and allow the person or object in the background to fall out of focus, you are creating depth in that photo.

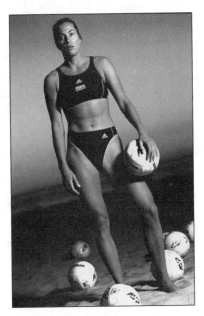

Figure 7.3 *In this photo of professional volleyball player Nancy Mason, the photographer has created the illusion of depth with both the lighting and placement of the volleyballs fading into the background.*

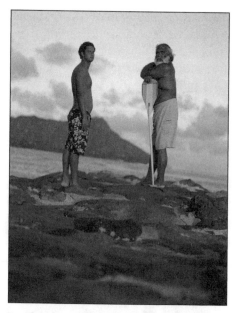

Figure 7.4 *By leaving the foreground and the background out of the field of focus, the photographer created the illusion of depth in this photo.*

Depth of Field

Depth of field is another important piece of the puzzle of basic composition. Depth of field is the sharply focused area within the frame. Everyone has seen pictures of people or a group of people staggered within a frame, some closer to the camera, others farther back. You've probably noticed that some are in sharp focus, and others are not.

Those who are not in focus are outside the depth of field, or area of focus. By having a shallower depth of field, with people in the background slightly out of focus, you are giving the photo the added dimension of depth.

Tricks of the Trade

Many photographers use a technique called selective focusing to limit their depth of field and, thereby, create the illusion of depth. To do this, you focus on one specific portion of the frame while intentionally throwing the remainder of the frame out of focus. This technique also draws the viewer's eye to the portion of the photograph that is in focus, in essence encouraging viewers to see what you want them to see.

A shallower depth of field is created by using a lower aperture number, such as f/2.8. The higher aperture numbers, such as f/16.0 or f/22.0, will give you a greater depth of field because they allow more of the frame to fall within the focus range.

As an example, using the group of people just mentioned, you can put all of them in focus by using a faster film (one with a higher ASA/ISO number), such as an 800 or 1000, and combine that with a higher aperture number setting. This will

essentially give you a deeper field of focus. Although this increases the depth of field, it doesn't necessarily add to the dimension of depth.

Tricks of the Trade

Each lens will not give the same depth of field with the same settings. For example, if you set your camera to f/5.6, and shoot with a 24mm wide-angle lens, you will have a greater depth of field than if you used a 300mm telephoto lens with the same aperture setting.

Filling the Frame

Obviously, the frame of every photo is filled with *something*. What you choose to fill the frame with is an element of basic composition. Your main subject notwithstanding, the way you fill or don't fill the rest of the frame is a big part of every photograph. The ways in which you fill the rest of the frame should add to your photo and give it more impact, or allow it to tell a more complete story. If you don't fill this space wisely, you'll detract from your subject, and the results will be a lot less satisfying.

When photographers set out to create a striking image and use the background as a key element in the frame, many times they will use the formula known as the rule of thirds.

The Rule of Thirds

Here's a quick rundown on how to use the rule of thirds: Whether it's a vertical or horizontal photo, begin by breaking the frame down into three equal sections. If you are going to take a picture of someone playing soccer, you might want to put him in the left side of the frame dribbling the ball and have the people chasing him in the other two sections. If you're shooting an automobile, you might decide to have it stretch across the frame horizontally, but situate the car in the middle third of the frame vertically, leaving the ground to fill the bottom third of the frame and the sky to fill the top third. If you're taking pictures at a dog show, you might focus your favorite pooch in the center section and include other dogs less prominently to the right and left of your primary subject.

Even though your main subject should be the focal point of the image, it doesn't have to be smack dab in the middle of the frame. Instead, think of it as the most important piece of the puzzle. Everything else should be designed to portray the subject in the fullest and most complete way.

Figure 7.5 *Although the photographer has nearly filled the frame with this motorcycle, he has left enough room at the top so that the grandstand of the racetrack is visible. By including the racetrack in the frame, the photographer is telling viewers this is a racing cycle.*

Using Negative Space

As noted in Chapter 6, negative space is space within the frame that is virtually empty. You can use negative space to enhance your photograph, sometimes more effectively than if you filled the frame of your photo with your subject. Suppose you're at the airport and decide to shoot a photo

of a plane taking off. If you catch the plane heading upward and keep it in the lower left-hand corner of the frame, the rest of your photo will simply be the sky, or negative space. But because the plane is headed upward, into the negative space, it gives the photograph more impact than if you had simply filled the frame with the plane, leaving little or no negative space.

Think about a painting sitting by itself on a blank wall. That painting will have more impact being surrounded by the "negative space" of the blank wall than if it were situated amidst 15 other paintings. In this same sense, negative space in a photograph can enhance the subject in a special way.

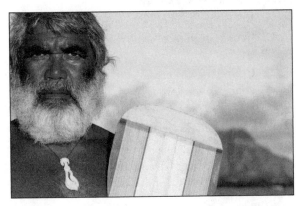

Figure 7.6 *By placing the subject of this portrait to the left of the frame, the photographer was able to catch the beauty and majesty of Diamondhead Crater in Hawaii in the background. This illustrates a very effective way to use the negative space in the frame.*

Negative space doesn't have to be completely empty or flat. You can include objects in the negative space that support the main subject or story of the photo or identify where the subject is. If you include a roller coaster in the background looming over a smiling youngster, it will be pretty obvious that he's at an amusement park. The silhouette of the roller coaster against the sky is part of the negative space in the frame, but it's helping to explain the happy look on the face of the subject. This kind of thoughtful use of negative space serves to enhance the photo, much the same way an adjective helps amplify a noun.

The Least You Need to Know

- By learning the principles of basic composition, your photos will tell a more complete story.

- Contrast helps create an illusion of depth in your photographs.

- Depth of field is the amount of area in front of and behind your subject that is in focus.

- Leaving some negative space in your photos can sometimes have more of an impact than if the subject filled the entire frame.

Chapter

Shooting Indoors

In This Chapter

- Making sure you have the right equipment
- Framing your subjects without clutter
- Using windows for light and enhancement
- Adding light for the best overall effect

It's always great to be outdoors shooting photos on a warm sunny day, but sometimes there's no way to avoid taking pictures indoors. Perhaps you want to take portraits of your family to mark a special event, or maybe just shoot some candid photos of the kids at play. Although you have to consider a number of additional factors when taking pictures inside, indoor photography can be just as striking as photos taken outdoors.

In this chapter, we cover the principles of indoor photography. They include the proper way to frame your photos, avoiding clutter, working with a combination of natural and artificial light, and

with purely artificial light. With a little practice, you can shoot indoors with the same confidence that you do in the open air.

The Right Equipment

You don't need to go out and buy a separate camera to use indoors. You can use your basic camera, whether SLR or point-and-shoot, to take photos inside. However, because there is less available light indoors, you might need wider aperture lenses for your SLR, or faster film for your point-and-shoot. In addition, if your camera doesn't have a built-in flash, you'll need to mount a flash (on your SLR), or use a very fast film (in your point-and-shoot). If you are going to be taking portraits, a tripod can be a valuable piece of equipment because it will allow you to keep the camera steady while shooting at slower shutter speeds. A cable release will also come in handy, so you can watch your subjects without looking through the viewfinder.

In some cases, if you want to create special lighting effects, you might consider using a remote flash unit and a stand on which to mount it, as well as a remote mechanism to fire the flash. These aren't absolutely necessary, but as you begin to shoot a variety of indoor photos, you might find that the remote flash is a handy tool to have around.

Now that you know what equipment you need to shoot indoors, let's start setting up your shots.

 Tricks of the Trade

One advantage to having a digital point-and-shoot as opposed to the standard film point-and-shoot is that many digital point-and-shoot cameras will allow you to adjust the ASA setting to compensate for lower lighting conditions. With the standard film point-and-shoot you've got to change the film itself to compensate for these conditions.

Don't Clutter

When shooting indoors, many beginning photographers accidentally ruin an otherwise good photo by failing to take into account the placement of everyday household objects in the frame of their photos. Although lamps, plants, toys, and other objects may appear innocuous to the naked eye, in your photographs they often become unwanted and annoying clutter.

This "clutter" can be in the form of a large plant in the background that appears to be growing out of the back of someone's head, or a chandelier that obscures part of a face. A dark picture frame hanging on the wall with a subject's head in front of it will sometimes blend in with the person's hair, making his or her head appear square!

You also need to be on the alert for clutter in the form of indoor sources of light. An overhead light can produce a glare, or an out-of-focus candle arrangement in the front of a subject at a table can actually appear to be burning the subject's face. And, of course, a mirror or glass-framed photo or painting on the wall can reflect the flash in a way that will absolutely ruin the photo.

Once you identify the clutter, you can move the offending object(s) a few inches to the right or left, move your subject slightly, or shoot the photo from a slightly different angle. If there's anything in the background that might reflect the light from a flash or even the image of the person taking the picture, changing the angle may help, but if the object is too large, you might have to reposition your sub-jects completely.

 Out of Focus!

If you worry that the photo you want to take is going to produce an unwanted glare, but otherwise love the way it is framed, you can attach a polarizing filter to the front of your lens to eliminate the glare. By adding the filter you are de-creasing the amount of light coming into the camera, so you must adjust your expo-sure settings accordingly.

Unwanted clutter can easily creep into your indoor photos. Fortunately, it won't take long for you to recognize it *before* you click the shutter.

Tricks of the Trade

Consider taking an indoor photo from several different perspectives. As with outdoor shots, every time you change positions or angles, you get a different result.

Working with Windows

When you're shooting indoors during the day, there's likely to be a source of natural light coming through one or more windows. You can use this natural light to achieve a variety of different effects. A bright shaft of sunlight coming through an open window will give you a strong, angular look with hard, direct shadows. More diffused lighting coming through an opaque curtain will create a softer effect, which is more flattering for shooting portraits of people. As a photographer, you've got to find ways to make that light work for you.

Consider using the light from a window as the primary source for the photo. You can simply move your subject within the shaft of light or place him close enough to it so that it illuminates him properly. Or you can use the light from the

window to create shadows within the room while a secondary light source, either a lamp in the room or a flash unit, becomes the primary or fill source.

If the light coming through the window is too distracting or creates harsh, unwanted shadows, try pulling a curtain or shade to eliminate it or at least tone it down, and then augment your photo with artificial light—either a flash or other light within the room.

Figure 8.1 *This shot doesn't benefit from the light coming in the open window. You can see the reflection of the window in the large picture on the wall and, in this case, it does not add to the desired impact of the photo.*

Figure 8.2 *This is the same photo, but with the curtain drawn to soften the light from the window. Now there is no reflection and the entire photo has a softer look. The large picture on the wall now adds to the photo instead of detracting from it when the window was visible.*

Tricks of the Trade

If you want to include a very strong shaft of light in a photo for its depth and texture, use your light meter to measure the ambient light in the room, not the bright light from the window. By doing this, you'll properly expose the room while still allowing the shaft of light from the window to bring a strong presence to the photo. This effect can produce a much more dramatic photograph than if you were to tone down the light by balancing the exposure.

Adding Artificial Light

You can increase the impact of indoor photos by adding light to the composition of the frame. And we're not just talking about using your camera's flash unit. Whether it's an overhead light or a simple candle on the table, that light will affect your photo. A Halloween pumpkin sitting on a table by itself won't change the look of the photo, but put a candle in that pumpkin and you've really made an impact.

Here are some ways that indoor light can impact your photos:

- If you turn on every lamp or overhead light in the room, you will end up with a generic photograph that feels very flat with no depth and no structure to your lighting.

- If you add a flash, it will simply illuminate the same scene more, but won't alter the overall mood of the photo. Again, there won't be any structure to the lighting.

- By adding a couple of lighted candles to illuminate your subject, you'll get a warm, glowing, romantic effect that might enhance your shot.

- If you only have candles burning and need a flash for sufficient lighting, you can use one of many warmish yellow filters or *gel filters* over the flash in order to preserve the warm feeling created by the candles, yet still properly illuminate the entire photo.

Shutterbug Lingo

Filters used to change the texture and color output of the flash are called gelatin or **gel filters.** They are pieces of translucent plastic that come in various shades and can be taped directly over the flash unit.

- The flames from a burning fire in a fireplace or woodstove can accentuate an indoor photograph. The fire can be augmented by lamps in the room or by a filtered flash and still lend the scene a warm, homey feeling.

- You can turn out all the lights in the room and use just the flash on your camera, the single source of light giving the subject a stark, almost eerie feeling.

Tricks of the Trade

One creative way to use a remote flash is to place it on a stand outside a ground-floor window so that it will produce another source or angle of light. It can produce the same effect as a bright shaft of natural sunlight, or it can be filtered to produce a variety of colors and warmer tones.

When shooting indoors, be creative and be willing to experiment.

The Least You Need to Know

- Although you can use the same camera to shoot indoors that you use outside, you might need a tripod and remote flash for certain kinds of shots.

- Before shooting a photo indoors, always check for objects that might clutter the frame.

- Use any natural light coming through a window to the best advantage. It should add to, not detract from, the photo you want.

- Don't be afraid to experiment with different forms of artificial light to alter the feel of your photos.

Shooting Action and Sports

In This Chapter

- Making sure you have the right equipment
- Capturing speed and angles
- Freezing the action
- Shooting sequences and multiple exposures

A great action shot always captures everyone's attention. The image implies speed and movement. Whether it's the world surfing championships or your child's soccer game, capturing the action requires a thorough understanding of your equipment. That means using the appropriate cameras and lenses in conjunction with the various films available. You also need a good eye, must know the proper distances and angles from which to shoot, and be sure your lighting is conducive to the type of photo you are trying to create.

In addition to a single action shot, you can shoot sequential images that capture movement in rapid succession, or you can shoot multiple exposures in a single frame.

Action photography involves a little more planning and skill than other types, but with knowledge and practice, you can capture the action at a softball game or a race, or of one of your kids hurtling down a hill on a snowboard.

Choosing the Right Equipment

Action photography requires cameras that have shutter speeds above $\frac{1}{250}$th of a second. That means you can't use a typical inexpensive point-and-shoot. They simply aren't capable of capturing quality action photographs. When you choose a camera for action shots, you'll want a standard or digital SLR. Additionally, you must be sure the camera has interchangeable lens capability so you can switch from one focal length lens to another.

Aside from the camera with a fast shutter speed, a variety of lenses, and the right film for the job, it's also advantageous when shooting action photography to have a camera with a motor drive or power winder to advance the film. This device will allow you to capture photos quickly—thus getting more of the action—without having to stop and wind the camera manually. If you have to stop to wind, you may miss the opportunity to get the best shot of the day. You can buy a power winder to attach to your camera for between $50 and $200 if your camera doesn't have one already built in.

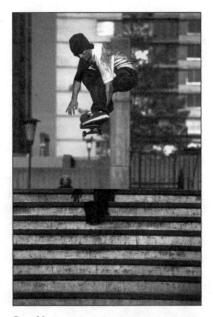

Figure 9.1 *Action sports photos can be taken almost anywhere. Here the photographer captures a skateboarder jumping down a series of steps.*

Lenses

Photographers typically use telephoto and wide-angle lenses when shooting action and sports. Such lenses enable you to shoot close-ups from the sidelines of a soccer field, or from the top of the bleachers of a baseball game, or even standing on the beach shooting a surfer as he comes down the face of a large wave. For a full description of these lenses, see Chapter 3.

Tricks of the Trade

Instead of bringing two or three telephoto lenses with you, you can always bring a zoom lens with the capability of shooting from a number of different distances.

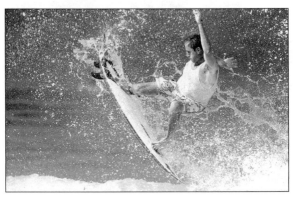

Figure 9.2 *This photo of professional surfer Ross Williams was shot with a supertelephoto 800mm lens from about 75 feet away. It concentrates solely on the aerial maneuver being performed, the combination of surfer, board, water, and spray giving the photo a strong sense of action and speed.*

Film

You need to choose your film based on the lighting conditions you find yourself in. For example, if you know you're going to be shooting in a dimly lit high school gymnasium, you'll need to use

a faster film with a higher sensitivity rating, such as 400, 800, or even higher, to allow proper exposure.

Conversely, a bright and sunny soccer field requires a film with a lower sensitivity rating, such as an ASA 100 or 200 rating. This film, coupled with the proper shutter and aperture settings, will allow for the correct exposure in order to compensate for the lighting conditions.

Exposure Settings for Action

There are several ways to set your shutter speed and aperture when shooting action. If you approach your photo shoot with a goal to get crisp, sharp action photos, you'll need a very high shutter speed ($1/1000$th or higher) and your aperture will have to be open to a greater degree. This allows more light in and stops the action as you shoot for a proper exposure. If, on the other hand, you want to create the illusion of movement by having motion or speed blur in the photo, then you should use a slower shutter speed (around $1/60$th or $1/250$th of a second) and close down your aperture to allow less light to reach the film.

After you begin seeing the results with various settings, you'll have a better idea of the kind of photos you want and how you can best achieve them so that they have the impact you expect.

Lighting Your Subject

When shooting outdoor action, the available natural light will often be sufficient. But there will also be times when you have to augment what's already there in order to highlight your subject, fill in shadows, or create a desired effect.

If you are able to get close to your subject, such as photographing your child doing a trick on his skateboard, you can use your camera's flash unit to fill in shadows and highlight the colorful details in your photo.

 Tricks of the Trade

When the sun is behind your subject, don't forget about the possibility of using it as backlighting. Instead of using a flash to fill in shadows, you can allow the sun to create the kind of shadows that will add to the photo and give it impact. However, remember to adjust your exposure settings accordingly, to account for the fact that the front of your subject is now darker because he is no longer being illuminated by the sun.

When shooting from a greater distance, such as from the stands at a softball or soccer game, where your flash won't be effective, you must adjust your exposure values based on the existing lighting

conditions. For example, if you're sitting in the bleachers and using a telephoto lens to photograph someone at bat, you must adjust your shutter speed and aperture for the available light (using your built-in light meter) to properly expose your film. If you decide to move to another position, don't forget to measure the light and, if necessary, reset your exposure values.

Using Angles to Create Impact

Every photographer strives to set his photographs apart from the rest—in other words, to put his own personal stamp on them. Using angles is one way to achieve this goal.

Creating angles involves the position of the photographer. If you stand directly in front of a skier coming down a mountain and photograph him head on, you will flatten out the vertical perspective of that frame. As a result, you won't get the full effect of the slope of the mountain or hill. However, if you stand off to the left or right of the skier's path, you'll not only capture the motion of your subject, but also bring the steepness or angle of the mountain into the frame.

To get the greatest impact from your photo you must first survey the lay of the land. That may mean walking the racecourse or the perimeter of a ball field, climbing the bleachers, or simply walking down the beach. By surveying the area, you are training yourself to "see" the finished product in several different ways.

 Tricks of the Trade _____

> Shooting from a different angle will alter almost every action shot. If you stand on a ladder you get a completely different photo than if you are lying on the ground. The same applies to moving left or right, even though the subject is in the exact same place.

For example, if you want to shoot a surfer riding a wave, one way is to simply use a telephoto lens and get as close to him as possible. By doing so, you will capture the way he rides the board and the immediate spray of the water around him, which certainly can result in a high-impact image.

However, if you want to make the surfer part of the overall environment in which he is riding, you can change your lens for a wider angle perspective, then walk down the beach, stand on a rock jetty or sand dune, and capture not only the surfer on his board, but all of the waves breaking around him, the sand, the length of the beach, and maybe even onlookers in the background. Now you are telling a complete story through angle and composition, and one in which the surfer is just part of a larger picture.

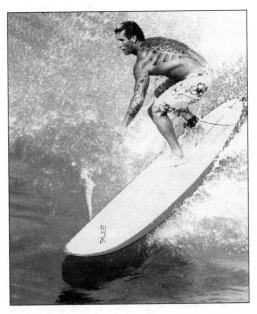

Figure 9.3 *The purpose of this photo of surfer Bobby Friedman was to focus on the physical nature of a well-conditioned top athlete using all his skills to come down the face of a large wave. There was no need to tell a more complete, wide-angled story.*

Vary the angles when taking pictures. If you're shooting a soccer game, don't take every photo from the same spot on the sideline. Move around and use your eyes as well as the camera lens to frame the next photo in your mind.

Don't worry about getting other people in the shot. If you capture a goal being scored, showing fans cheering in the foreground might be effective. Take

your time, check out the scene, and be creative. Soon you'll be repositioning yourself without even thinking. Finding and capturing different angles will become an integral part of your action photography.

Capturing Speed

There's speed, and then there's *speed*. It's one thing to photograph your son running from home to first after getting a base hit. But it's entirely another thing to photograph a racecar going around the track at 200 miles per hour. Although you may never shoot at the Indianapolis 500, you certainly may have occasion to photograph some real speed. For example, if you ever want to photograph a motocross race, where the bikes are moving at maybe 30 to 40 miles per hour and flying over jumps, you're going to need the proper techniques to capture the speed effectively.

Freezing the Action

Freezing a fast-moving object in your photograph requires a very fast shutter speed—$\frac{1}{1000}$th of a second or greater. Many professional photographers use shutter speeds of nearly $\frac{1}{8000}$th of a second when freezing the action (adjusting their apertures accordingly for proper exposures). Taking into consideration the composition and angles, capturing speed requires quick hand-eye coordination, knowing the exact moment to press the shutter, and the best angle for framing the shot and then freezing

the action just where you want it. If you miss the moment, you might find the front half of the motorcycle already out of the frame. Capturing speed skillfully takes a steady hand and lots of practice.

To set up correctly, you must begin by walking the track or course and finding a place to set up that will give your photography the perspective it needs as well as the best place to capture the speed. Instead of focusing simply on one bike or one car, it might be better to shoot at an angle that not only shows the subject, but also shows both where it came from and where it's going. Again, you're telling a story.

By positioning yourself at an angle to your subject, you might capture the dirt flying from the tires of the motorcycle as it moves into a turn with another bike right behind it.

Freezing the action is a great technique capturing the intensity of a subject. For example, if you're photographing runners competing in a hurdles race, you may want to use a longer telephoto lens and focus in on a runner's foot coming over the top of the hurdle as well as her chest and face as she leaps into the air. By freezing the lead foot as well as the intense expression on her face, you're catching both the speed and effort, and creating a real action photo.

Figure 9.4 *By capturing this motocross racer going through a tight turn as opposed to just coming down a straightaway, the photographer has created an image that shows dramatic motion and speed. Though the flying dirt partially obstructs the rider, it adds visual impact and originality to the image.*

By contrast, you can step back and shoot all of the hurdlers as they race over the track and, by freezing the action in this way, you're telling the same story from another perspective.

The main things to remember when capturing speed and freezing the action are as follows:

- Be sure to use the fastest possible shutter speeds to capture and freeze the action.

- Always survey the area around which the action takes place so you can create the best angle from which to shoot.

- Move in close to your subject to show intensity or use a wider-angled lens to paint a more complete picture.

- Use a tripod when working with a tele-photo or supertelephoto lens.

- Consider using faster film such as 400 or 800 ASA.

Blurring the Action

Instead of freezing the action crisply, you can create a "speed blur" effect, in which the moving subject will have a bit of blurriness to it, which lends the photo a real sense of movement. To achieve this effect, you simply slow down the shutter speed (and don't forget to adjust your aperture accordingly). Although you should experiment with the shutter speed settings you want, many photographers use a 1/60th or 1/125th of a second shutter speed and a panning motion when shooting fast-moving subjects.

Tricks of the Trade

When using a telephoto lens or super-telephoto lens, it's best to use a solidly built tripod to steady the camera while you're following your subject. Some supertelephoto lenses are so large and heavy that it's almost impossible to hold them and focus by hand.

Photographing Sequences and Multiple Exposures

Shooting a photo sequence enables you to document an activity from beginning to end. Instead of capturing a single moment of an event, you're telling the complete story via numerous closely spaced frames.

If you are photographing a snowboarder doing a maneuver in the halfpipe, you can certainly get a great photo by just shooting the top of the aerial as the snowboarder grabs his board and turns in midair. But by shooting the jump as a sequence, you can take three or four (and possibly more) shots of that same trick. Depending on the speed of your motor drive, you can show every aspect of the trick, from takeoff to the midair maneuver to the landing, and everything in between.

Sequences need not be limited to high-action sports. You can shoot a sequence of a baseball being hit or a golf swing, a soccer goalie diving for a save, or one of your kids on his BMX bike taking a jump in your own backyard.

Setting Up for a Sequence

When preparing to shoot a sequence, you first need to anticipate the points where the action will begin and end. Also, try to set it up so that you have a clean and unobtrusive background. The frame should contain your subject and nothing else, if possible.

You should also be aware of the FPS (frames per second) of your motor drive so you know how quickly to pan left or right with the subject. An average motor drive has the capacity to advance the film two or three frames per second.

Next, you must adjust your focus. You want to make sure that your subject is razor-sharp for the entire sequence. It's easier to get a sharp focus with a wider-angle lens because the depth of field is greater with the perspective of this type of lens. If you're using a telephoto lens, keeping your subject in focus throughout the shot will be more difficult. The longer the telephoto lens, the shallower its depth of field. Make sure your subject remains within that depth of field during the entire sequence, or you will have to re-focus while following the subject.

Shooting the Sequence

To capture the sequence, you'll need to pan your camera as you take pictures. Panning is the act of moving your camera at the same speed as your subject. When panning, you shouldn't jerk the camera. You want a smooth, flowing pan and, to achieve that, you've got to know how fast the motor drive advances your film.

The longer the distance of your sequence, the more panning you will have to do. If you're standing at a 90-degree angle to your subject, you'll have to pan a full 180 degrees to capture your subject from beginning to end as he passes you by.

Before shooting the subject, try to practice the cadence or tempo of your pan. If another person is jumping over the hurdle or racing down the speedway before your subject, you can practice panning with that person without actually taking any shots. Make sure to look through the viewfinder the entire time.

Depress the shutter as your subject begins his activity. Don't wait until he takes off. This way you have a foundation to tell the story. Then pan with your subject smoothly and solidly, while keeping the shutter release depressed and allowing your motor drive to do the work. Follow your subject until the maneuver is completed. It's not as difficult as it sounds and, with some practice, you will probably surprise yourself with the results.

Tricks of the Trade

Panning practice makes perfect! There's nothing wrong with stepping outside your house with your camera and practicing panning as cars go by. If your kids are running around the yard, practice panning with them. By practicing your panning techniques, you will be able to pan more smoothly when it's time to actually shoot a sequence.

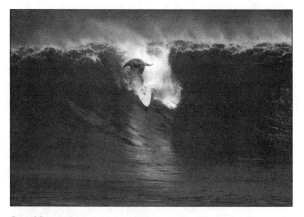

Figure 9.5 *This is the first photo in what was originally a 14-shot sequence showing every phase of a surfer riding a wave. Here we have three of the photos. In this first shot, the surfer has just caught the wave and is dropping in for his ride.*

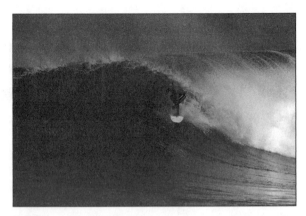

Figure 9.6 *In the middle of the sequence the rider is in the tube, or barrel, of the wave, where every surfer wants to be for an exciting ride.*

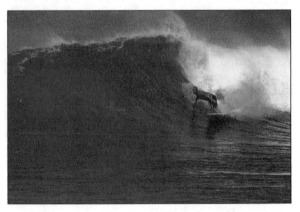

Figure 9.7 *In what was the final shot of the original sequence, the surfer has successfully ridden the barrel of the wave and is now kicking out as the wave breaks behind him. His ride, and the sequence, is complete.*

Out of Focus!

When professional photographers shoot a sequence, they always keep their eye on the composition of the frame. The subject is going to do what he's going to do, and it's the photographer's job to make sure the subject is never higher in one frame and lower in the next, or that the horizon line in the background is not tilted

Multiple Exposures

Multiple exposures are similar to sequences, but they are created on a single frame instead of spread over multiple frames. To shoot a multiple exposure, you have to be able to view the entire maneuver from a single position. You do not pan and you do not move the camera. In essence, you're letting the subject pass through the field of vision. To shoot multiple exposures, you must be able to override the film advancement feature on your camera. Many new cameras, both film and higher end digital, have an automatic multiple exposure feature built in.

After you've set your composition and focus for the shot, you simply depress the shutter and hold it as soon as the subject enters the frame. Your motor drive will allow the camera to capture images at the same rate of speed that it does when

shooting a sequence, but because the film is not advancing, your sequence now becomes a multiple exposure shot.

Multiple exposure photos can be a unique way to shoot sports and action. Once again, it takes practice, but look at it this way: If it doesn't work, you've only wasted one frame instead of a whole roll of film.

The Least You Need to Know

- Action photography requires cameras with shutter speeds faster than $\frac{1}{250}$th of a second.
- Action photography usually requires a wide-angle or telephoto lens.
- Action photography often requires the use of a faster film, such as 400 or 800 ASA.
- Shooting your photos from the proper angles will help you achieve the most impact.
- Always look for the best place from which to shoot, one that will allow your images to tell a more complete story.
- Shooting sequences and multiple exposures is a great way to capture action scenes.

Shooting Portraits and People

In This Chapter

- Taking pictures of people indoors and out
- Considering the lighting conditions
- Using shadows to create depth
- Getting your subjects to smile

Sure, you can take a whole bunch of pictures of people posing and mugging for the camera, and you might end up with a few good photographs. But if you don't apply some solid techniques when shooting portraits and people, including following the rules for framing and basic composition we outlined in Chapters 6 and 7, chances are that many of these shots will simply be a hodgepodge of snapshots.

This chapter covers the proper ways to frame, light, and take the best photos of people. Whether you're taking a formal portrait or a series of candid shots, you've still got to think like a photographer and look to create a photo with style and impact.

Portraits vs. Candid Shots

There is a difference between shooting a portrait and snapping pictures of people. A portrait is generally a much more structured photograph. As with all serious photography, you need to have a vision of the photograph you want to take. You need to think about how you want to pose your subjects, how you want the overall frame to look, and even the kind of expressions you want on their faces. You can take serious, funny, or even whimsical portraits. For kicks, some photographers even like to copy portraits from years past when the subjects often had blank looks on their faces.

Informal portraits are more like candid snapshots in that they appear less structured and there is usually less attention to the overall ambiance, but you should still put some time and thought into them. Whether you're taking a picture of a friend who spots you with your camera and strikes a hammy pose, or a serious photo of someone in deep thought or working on a project, these informal shots don't always have to be perfectly exposed or composed to be good. You're concentrating on the person, his expression, or what he's

doing, and you'll sometimes get a great photo without all the technical aspects being perfect. This is what candid shots of people are all about.

Choosing the Right Equipment

You can shoot a portrait with almost any camera. However, with the fixed 24mm or 35mm lens of a standard point-and-shoot camera, you can only shoot a portrait correctly from 8 to 10 feet from your subject. If you move either backward or forward, the subject will become dramatically out of proportion—shorter and wider. Yet, shooting from this distance with a standard 24mm or 35mm lens will always make the subject appear small in the frame. You can't get a good close-up or head-and-shoulders shot.

To shoot close-ups or tighter-framed portraits, you're going to need an SLR with a portrait lens, which is commonly between 80mm and 105mm in focal length. By using a portrait lens, your subjects will remain in true proportion—the photo will show them exactly as they look. The subject in Figure 10.1 was photographed using a 90mm portrait lens. If you tried to get that same tight shot with a point-and-shoot camera that has a fixed 24mm or 35mm lens, she would have appeared slightly out of proportion and distorted.

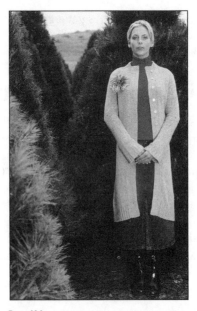

Figure 10.1 *This full-length portrait was taken with a 90mm lens. Had this photo been taken with a fixed 24mm or 35mm lens, the subject would appear slightly distorted.*

Here is a list of some other equipment you may need when shooting portraits:

- A flash attachment for most indoor applications, and possibly to soften shadows when shooting outdoors.
- An adjustable tripod, which will make it easier to take formal portraits.

- For self-portraits or group photos in which you're included, a self-timing feature on your camera, which will give you time to get yourself into the picture. The time delay ranges from 10 seconds to as much as two minutes, depending on the camera.

- A cable or remote control shutter release so that you don't have to look through the viewfinder after focusing for the shot and can watch your subjects more closely to capture just the right moment.

Posing Your Subjects

When taking a formal portrait, it's up to you to help your subjects strike an appropriate pose. However, just because it's a formal shot doesn't mean that your subjects have to be rigidly posed. Here are several ways in which you can set up for a formal portrait:

- If you're shooting just two people, one can be sitting in a chair with the other standing alongside or behind the chair.

- If you have a larger group, two or three can be sitting in chairs, the others standing between or behind them.

- If the event is a milestone, such as a graduation, you can show a father and son shaking hands, or perhaps both parents with their arms around their son's or daughter's shoulders and perhaps looking at the diploma.

- If you're using a fireplace as a background and including three or more people in your shot, arrange your subjects on either side of the fire. If there are just one or two people, have them both stand to one side of the fire.

- When photographing a large group of people, make sure one head isn't directly behind another, so that you don't end up with what appears to be two heads stacked on a single body.

- You can also ask people in a large group to turn at a 45-degree angle and turn their heads toward the camera. This will not only enable you to get more people in the shot but will also make everyone appear thinner.

Formal portraits don't always have to be serious. You can shoot a portrait-type photo with your subjects interacting to some degree, mugging for the camera, smiling, or laughing.

Tricks of the Trade

If you're photographing several people where some are standing behind others, always be sure to have your camera aperture set at f/5.6 or greater. By doing this, you'll create adequate depth of field and ensure that everyone will be in focus.

Shooting Portraits Indoors

As with all other facets of photography, lighting is the most important element when shooting portraits and people indoors. Poor or incorrect lighting will result in a poor quality photo. If you are setting up for a formal portrait, then you have the opportunity to create the optimum lighting conditions.

Let's say you want to photograph several family members (and maybe yourself) posing in front of the fireplace in your living room. Here's what you do: If you have a fire burning, that can set your tone for the photo. Bring your subjects in and then observe how the light from the fire falls on them. Measure the exposure value of the light using either the built-in light meter on your camera or a handheld meter. Now you have to determine whether you need more light, and that depends on the type of photo you want to take.

If you want a dark, moody shot, you might be able to use the fire as your primary source of lighting. Otherwise, you will need a front-lighting source to expose the subjects properly. Should you opt to use an on-camera flash, the lighting source that will illuminate your subject will come from the camera or film plane. This straightforward angle will have a tendency to flatten out the depth of the image, so make sure your secondary lighting is exposed as well. You can also use a remote flash placed off-camera to the side of your subjects, which will

create pleasing angles of light on your subject. Using a remote flash in this way can help give the photo added depth.

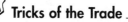

Tricks of the Trade

> For basic indoor photography relying on some ambient light and a flash, use ASA 200 or 400 film. This will allow you a broader exposure range, as well as enable you to shoot at a faster shutter speed and/or smaller aperture setting. Using this combination of film and exposure settings, you will reduce the risk of having blurred or underexposed subjects.

When you decide to photograph someone in a less formal setting, you won't have a lot of time to set up and create the combination of ambient and artificial light. It's either there or it isn't.

The best way to shoot this kind of photo is to simply put your camera on the automatic exposure setting and let it do the work for you. You can concentrate on catching your subjects at just the right moment, and your camera will do the rest. It will dictate the proper exposure for each shot and even determine whether the flash will fire. In other words, the camera will determine the overall lighting requirements of the frame.

Shooting Outdoors

When shooting people outdoors, you are always going to be contending with the light from the sun. The sun will give you a variety of looks around which to build a photo. We have already given some basics for shooting in natural light in Chapter 5. Here are some specifics to look for when photographing people outdoors.

The most important factor is the exposure palette on the face of the person. This can sometimes be a little tricky because you can't control the sun. Rather, you have to work with it. You may favor a certain location for a formal outdoor portrait but find that you cannot shoot it successfully at a certain time of day. For example, the midday sun might be so bright that it creates unwanted harsh shadows under the eyebrows, nose, and chin. This will give the subject a very unflattering look.

If you take the photo in that same location late in the day (see Figure 10.2), the setting sun might provide the perfect angle and softness of light for you to take an outstanding photograph. You'll be able to see the difference by simply looking through the viewfinder at these two very different times of day. You can always soften the light by the use of flash or filters, but it's best to wait for the natural light to fall in just the way you want it.

Figure 10.2 *This close-up headshot was taken in the late afternoon sun, which created soft side shadows with the photographer using a fill flash to illuminate the eyes and front of the face.*

You should avoid shooting with any kind of glass background, such as storefront, because the reflection will likely leave a big bright spot on your photo, or produce a reflection of you and the group you are shooting. By the same token, a very bright colored background, such as a white wall, should only be used if your subjects are dressed in dark clothing. Otherwise, you won't achieve the kind of contrast you need for an effective photo. See Chapter 7 for additional information on contrast.

 Tricks of the Trade

If you must shoot a formal outdoor portrait when the sun is very harsh, you can compensate by doing a number things. You can move around and try to find a better angle so that the shadows are not as prominent on the faces of your subjects. You can also use a flash to soften the shadows, or you can compensate by using a polarizing filter as described in Chapter 3.

Creating a Look

Creating a certain look in a photograph not only involves the expression on a person's face, but the entire package: the location of the shot, the clothes he or she is wearing, the way you use the lighting, and your choice of film. All of these elements will come together to give you the overall "look" of the finished product.

Figure 10.3 offers an example of a portrait that was taken to create a particular look for the subject. The cowboy hat was part of the wardrobe, and the mustache and beard are makeup. Next came the pose, which also helps set the tone and mood of the overall image.

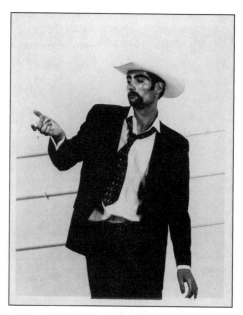

Figure 10.3 *This photo was taken to create a unique look for the subject.*

If you're photographing a bride and groom, a formal portrait will certainly look better if they are still wearing the attire in which they were married. Here, the clothing helps tell the story. If they have already changed into informal attire to leave the reception, you're then getting a more candid shot which can be very effective, but which doesn't tell quite the same story.

By the same token, if you want a shot of your son on his skateboard, it will be more effective if he is wearing the clothing he uses when he actually rides

the board—including helmet, elbow, and kneepads. By matching his attire to the activity, you are giving the photo a more realistic look. If you shoot him standing on the board in his school clothes, it's not quite the same thing.

Conversely, if you are photographing someone on a bitter, cold, windy day and they are so bundled up that you can barely see their face, you'll get a photo that tells you more about the weather than the person. That kind of photo still tells a story, but perhaps not the one you wanted.

Using Shadows

As mentioned previously, using shadows properly in your outdoor photos will help give them depth and character. Shadows are created by a light source, but can be controlled by the photographer to a great degree. Although certain shadows can create a harsh effect on your subject, you want to be careful not to eliminate them entirely because your photos will then have an almost flat look. Instead, you should strive to use shadows to achieve the most flattering image of your subject.

You can control the shadows by looking at your subject from different angles and seeing just where the shadow falls from each location. Or you can move the subject, which will also change the location of the shadows.

For instance, suppose your subject has a rather rounded or pudgy face. If you set up your shot so that there is a strong shadow on one side of his

face, it will elongate the subject's face and reduce the appearance of roundness. You are not changing his appearance, but by the use of a shadow you are able to give him a more flattering look.

Tricks of the Trade

We have already talked about a way in which a flash can soften harsh shadows, but you can also use the flash to create shadows. For instance, if you want a shadow to fall on the right side of your subject, you can shoot the photo with a flash from an angle on the left side of the subject. You can also control the angle of the shadow by making a minor adjustment to the angle of the flash.

Say Cheese: Getting the Right Expression

One of the most vital elements to successfully photographing people is the expression on their faces. Press the shutter before they are ready, and you never know what you might get. You certainly don't want a photo where someone is looking away, talking, touching their face, or standing there with a goofy expression.

Here are some things you should do in order to capture the look and expressions you want:

- Establish a trust level. Be firm and decisive when posing your subjects and getting ready to shoot. That way, they will have the confidence that you know just what you are doing.

- Make sure everyone appears comfortable. If someone is fidgeting, adjusting their clothes, or jostling for position, then wait. Give everyone time to get set.

- Create a relaxed atmosphere. You may want to turn on some music, crack a few jokes, or just chat informally for a few minutes, until everyone appears completely relaxed and looks forward to your shooting the photo.

- Give your subjects final instructions. If you want your subjects to smile, say so. If you feel the photo would be more effective with a serious look, tell them that. You are the director. What you don't want is two people giggling, and the other two looking somber.

- Watch your subjects carefully through your viewfinder, or if you have a cable or remote control shutter release, just look directly at them. When they have that right expression, take the photo.

The Least You Need to Know

- Make sure you have the right equipment for taking pictures of people. Besides the camera, this may include a tripod and cable release.

- Lighting is often the key to a successful portrait. You can often combine natural ambient light with an artificial source of light, such as a flash.

- Shadows can both add to and detract from a photo. Learning to make the proper use of shadows will make you a much better photographer.

- Look for the right moment to press the shutter. The expressions on the faces of your subjects can make or break the photo.

Shooting Landscapes and Scenery

In This Chapter

- Taking advantage of existing light conditions
- Envisioning your photo ahead of time
- Finding the right mood
- Capturing the perfect frame

Landscapes and scenery have always been favorite subjects for amateur and professional photographers alike. Unfortunately, a lot of amateurs have a hard time capturing in a photograph the beauty of a scene they see with the naked eye.

But by following the basic rules of composition, training yourself to see the photo ahead of time, and then framing it correctly, you'll find that you can really get some great images.

Choosing the Right Equipment

Because most landscape photographs are shot with wide-angle or moderate focal-length lenses, you'll likely need an SLR camera. However, most point-and-shoot cameras today come with a zoom-capability lens that enables you to do some wide-angle shooting; some point-and-shoot cameras even have a *panoramic feature*, enabling you to take wide-angle landscape photos.

Shutterbug Lingo

With panoramic cameras you can take extreme wide-angle landscape photos. Some point-and-shoot cameras have a **panoramic feature,** which masks, or crops, the vertical edges on both the top and bottom, giving you a panoramic or wide-angle view.

Ideally, however, you should use an SLR for land-scapes and scenery. Because the SLR has more manual capabilities, you can create a more complete image with it. That doesn't mean you can't use a point-and-shoot camera to take some fine photos of Niagara Falls or Old Faithful. But by using your SLR, you can decide where you want to emphasize the focus, how you want to adjust your exposure settings, and what you want the overall

look to be. In other words, you can create photos with the maximum impact and substance.

With landscapes and scenery, a tripod also becomes an important part of the equation. Often when shooting scenic vistas, or even close-ups of flora and fauna, the camera must be perfectly still. By mounting the camera on a tripod, you can fully study the subject without having to hold on to the camera.

If you want a greater depth of field, a tripod becomes a necessity. To get increased depth of field you'll probably need to set your camera's aperture at f/22.0 or greater, and that means your exposure time will also increase dramatically—for a full second or more. There's no way you can handhold a camera perfectly steady for this amount of time and get a sharp image; you'll need to mount it on a tripod.

Other equipment you might consider using when shooting landscape and scenery includes …

- A cable or remote control shutter release so that you don't have to risk jostling the camera when snapping the picture.
- Several lenses for shooting scenery from different distances and to achieve a variety of effects.
- A number of filters to compensate for unsatisfactory lighting conditions or to enhance color.

Finding and Seeing the Light

An important element of shooting outdoor land-scapes and scenery is finding the best light. This is one type of photography where you won't use flash. You'll be relying entirely on natural light and, therefore, you've got to be able to see how it falls on your subject and how you can use it to the best advantage.

Suppose you want to photograph a unique-looking cluster of trees in a forest. When looking for the best place to shoot the scene, you notice that, from most angles, the foliage is so thick that virtually no sunlight shines through. From a certain angle, though, you can see bright shafts of light penetrating through the branches. Including the shafts of light in the frame will give the photo character. With portions of the trees illuminated by the light and the rest in shadows, the photo might take on an almost surreal quality and give the image a much greater visual impact.

Or consider taking a picture of a waterfall. If you photograph the waterfall head-on, it will look flat. However, if you find an angle that captures the sunlight reflecting off the cascading water or back-lighting the foliage around it, you've got a beautiful shot. If you shoot from an angle, the water will have depth and you might even capture the separation between the flowing water and the rocks behind it. If you look hard enough, you might even find a spot in which the combination of spraying water and sunlight creates a rainbow.

Tricks of the Trade

When shooting landscapes, you'll sometimes be forced to deal with an unusual lighting condition. For instance, say you're trying to photograph a sunset but there's a glaring shaft of sunlight coming through the clouds that you think will ruin your shot. Think again. Sometimes unusual lighting can actually give your photo character by creating a unique mood. Don't shy away from taking a photo under these circumstances. Try to find a way to make the light an integral part of the image.

Say you come upon a picturesque lake, and the sun is coming in and out of the clouds over the water. Pay attention to how the sun comes through the clouds at the various intervals. Are shafts of lights creating interesting reflections on the water? Are there times when the sun is completely obscured by clouds? Shooting the scene when the light is reflected off the water will make for a much more interesting photo than if you were to take the picture when the sun is completely obscured by clouds.

And keep in mind that light changes character throughout the day. You may decide you like the light better at 4 P.M. when the light is warm and soft due to its angle, than at 10 A.M., when it's

much more direct and harsh. It's up to you to decide which lighting structure you feel is best for the photo you want.

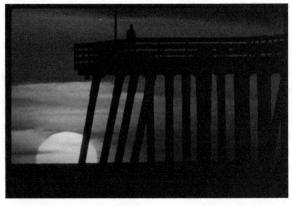

Figure 11.1 *The vibrant colors of the setting sun are what inspired this image. To capture its essence, the photographer framed the sun with a solitary man watching the sunset at the end of the pier, giving personality to the photo. He used an 800mm supertelephoto lens and shot the scene 300 feet from the end of the pier.*

Tricks of the Trade

It's worth taking the time to learn to "read" various lighting conditions and find the best light for the kinds of photos you want to take. You can hone this skill by taking pictures in various lighting conditions and comparing the results.

Creating a Mood

Creating the right mood when you photograph landscapes and various types of outdoor scenery is the key to giving your images real emotion. Consider the difference in mood between a photo of a beautiful sunset over a city skyline and a picture of a dark, menacing storm cloud that looks as if it will open up at any moment. The two images of the sky are completely different, but by setting the proper mood, both photographs can have emotional impact.

Figure 11.2, a photo of Villa-Rica Pucon, a volcano in southern Chile, is a perfect example of the photographer creating a mood by shooting in the late afternoon sun. The combination of shadow and light adds to the overall image. If this photo had been taken in the harsh light of the midday sun, the volcano would have appeared as pure white and flat, with no shadows to reveal the mountain's interesting textures and shapes.

It's up to you as the photographer to set the tone that will capture the real mood of the photo. Take a dark storm hovering over an open plain in the Midwest. These kinds of clouds can spawn violent thunderstorms or tornadoes. If you decide to photograph such a scene, part of the mood is obviously already there—the threat of a storm. But you can make it even more emotional by looking around before you shoot.

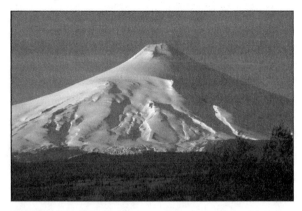

Figure 11.2 *The Villa-Rica Pucon volcano in southern Chile shot in the late afternoon sun.*

 Out of Focus!

When shooting landscapes and scenery, you may occasionally find yourself in dangerous weather conditions. If a thunderstorm is imminent, seek shelter immediately, especially if you're working with a metal tripod and camera. Remember also that rain, dust, or particles of small debris can damage your camera.

Suppose you simply frame the cloud hovering over the open field. That image in itself can be somewhat menacing. But if you spot a farmhouse and barn nearby, with some people scurrying about,

trying to get livestock to safety, you have the opportunity to create even more mood. By including the buildings, livestock, and people in the frame of the photo, you are now capturing the full emotion of the scene with a strong sense of the inherent danger.

Adjusting Your Exposure Settings

By making certain adjustments to your aperture and shutter speed settings, you can get some unusual and interesting effects.

Suppose you take your kids and your camera to a carnival, and you notice how the Ferris wheel up and towers over the rest of the rides. You decide to take a photograph of the interesting scene before you. You take the photo at midday and from what you think is the proper angle. The result, however, is a very bright picture top lit by the midday sun, with virtually no shadows and little photographic impact. Disappointed with the result, you decide to return just before sunset and take the same photo.

What a difference a few hours can make.

Taken at twilight, your photo features long, dramatic shadows resulting from the setting sun striking the Ferris wheel. The lights on the various rides are now illuminated and, combined with the shadows from the setting sun, create additional separation and depth. By taking the same photo

in a very different kind of natural lighting, you have changed the mood completely and created a more dramatic image.

Tricks of the Trade

To change your late-afternoon photo of the Ferris wheel even more, try shooting it at a slow shutter speed, 1/30th of a second or slower. At this speed, the lights on the moving Ferris wheel will appear as a continuous circle of light as opposed to distinct points of lights that are frozen in time. Don't forget to use a tripod so the camera remains steady.

Using Filters

By using color-enhancing or special-effects filters, you can also alter the mood of an image. Let's say you decide to photograph a scenic running stream. But the lighting just isn't right; the sky is pale blue and not very deep, and the sun is glaring into the water from directly overhead. Instead of walking away without taking a picture, you can dip into your bag and select a filter or combination of filters.

A polarizing filter, for example, will remove the glare from the water, and the addition of a color-graduating filter will convert the dull sky into one of radiant color. Depending on the filter, you can

make the sky red, orange, green, or deep blue—whatever you feel will have the most impact.

Don't be afraid to use your filters and try various combinations. Remember, there is no one perfect mood for each photo. As a creative photographer, you have the ability to alter the mood by both natural and artificial means.

Framing for Visual Impact

When shooting landscapes and scenery you often have a wide visual field in front of you. If you're photographing a mountain, or a beach along the ocean, or even the skyline of a big city, you can't always fit everything into the frame. So you've got to frame the area that will give the photo the most impact.

When you're framing landscapes and other scenery, here are some things to keep in mind:

- Remember to see the story first in your mind's eye. Then make sure the things you see are within the frame.

- Create interesting angles. Don't automatically shoot everything head-on. By walking several hundred yards down the beach and then setting up at a low angle, the photographer was able to take the striking photo of a long pier at sunset seen in Figure 11.3.

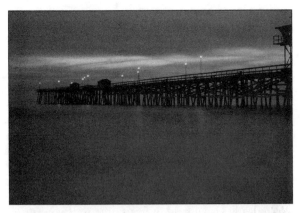

Figure 11.3 *A long pier at sunset.*

- Always consider the light. Make sure the existing light and the shadows it creates adds to your photo and doesn't detract from it. In Figure 11.3, notice the varying light in the sky and also the lights on the pier, all reflecting off the water. Viewed in color, this photo shows an incredible variety of vibrant, reflecting colors.

- Don't be afraid to use negative space in the frame. For example, don't shoot a scene at such a low angle that the sky isn't in the photo at all. Get a creative balance within the frame.

- Look for something that may add to the story you want to tell. The view of the ocean in Figure 11.4 includes a jet ski and a warning sign. The dark clouds over the ocean, combined with the warning and

the absence of a person give this image a
sense of foreboding.

- If you're photographing a vast landscape or
 a very large geographic feature, including a
 recognizable subject such as a person, ani-
 mal, or car will help to establish the size of
 the subject.

Figure 11.4 *View of the Pacific Ocean at sunset.*

Tricks of the Trade

If something doesn't look quite right in
your frame, don't hesitate to move for-
ward, backward, or to either side. By
moving just a few feet, you might change
the angle or content of the frame just
enough to get the result you want.

The same basic rules for framing a photo apply to all aspects of photography. Shooting landscapes and scenery might seem more daunting because of the combination of larger subjects and empty space. However, it's still the little things that count, and getting those details in the frame can make that photo come to life.

The Least You Need to Know

- An SLR camera gives landscape photographers many more options than a point-and-shoot.

- Many landscapes and scenes should be shot with a wide-angle lens and in natural light without a flash.

- You can get a completely different image by shooting the same scene at different times of day.

- Creating the proper mood for your landscape photos will give them real emotion and tell a more complete story.

- You'll often be photographing large areas. Take care to get the most dramatic, beautiful, or interesting aspects of the area into the frame.

Processing

In This Chapter

- Processing your negatives and slides
- Working with digital images
- Using digital imaging programs

There are three steps to photography as a whole. The first is setting your exposure, when you actually take the photo. The second is processing the exposed film, and the third is producing the finished prints. Digital imaging skips the chemical processing stage, though some forms of digital photography require processing via an imaging software program. Finished prints can be produced from black-and-white or color negatives, from your slides, or from your home computer by simply printing the images from your digital computer file.

Although this chapter doesn't go too deeply into the technical aspects of chemical processing, it does discuss the options that you have with your negatives, slides, or digital images. It also describes

the basics of computer imaging software and how you can use your home computer to solve some common photographic problems.

Black-and-White and Color Negative Film

After you finish shooting a roll of film, you'll need to have it processed. Processing today is much more consistent and stable than in past years. Higher-quality films and chemical processes make it relatively easy for all kinds of facilities to do the basic processing in the same manner. If you aren't asking for a special application, a one-hour photo center will do the same quality job as a custom pro lab.

The most common method for processing negative film is called Kodak C-41. This method processes your film so that it is ready for printing. When you receive your finished prints, you'll also receive several strips containing all the negative images from that roll. If you keep the negatives stored in a cool, dry place, you'll be able to have additional prints made.

Most processing facilities provide you with one set of prints along with the negatives when you pick up your order, though many labs now offer a second set of prints for a reduced price. The prints will most likely be printed on 4×6-inch paper for

both black-and-white and color films. If you request prints any larger in size than 5×7 inches, the processor will probably have to send the film to a specialty lab for processing.

You can also have the lab put all of your photos on a photo CD (compact disk). This disk will contain digital copies of your prints, which you can upload into your computer and then send to family and friends via e-mail. You also then have the option of making your own prints from your computer printer.

 Out of Focus!

> After shooting a roll of film, it's best to have it processed immediately. The longer it sits around, particularly in conditions where the temperature and humidity varies, the greater the chance of the film becoming compromised. Certain changes can cause color shifts and inaccurate exposures. Always have your film processed within a week of finishing the roll.

Slides or Transparencies

Out of Focus!

The negatives you get when you have a roll of color film developed are *not* the same thing as slides. Slides are "positive" images, whereas your negatives are, well, negative images.

Almost all slide films today are chemically processed in a similar manner. No matter what technique the processor uses, when you receive your developed film each slide will be mounted in a cardboard or plastic sleeve and can be viewed either with a projector, which shows the enlarged image on a white wall or screen, or with a hand-held viewer, which shows you a smaller version of the slide.

To have your slides converted to prints, you can simply take them to the same place where you have your film processed. Discount stores, pharmacies, or one-hour photo services will all send slides to a photo-finishing lab to have the prints made. This can take anywhere from a few days to a week.

As with their negative counterparts, today's slide films will retain their color stability for many years if they are stored properly in a cool, dry place.

Tricks of the Trade

There is a black-and-white slide film. It's called Scala and is developed using the Scala process. When processed, you'll receive the slides in the same cardboard or plastic sleeves as with color counterparts.

Digital Processing

Most digital cameras produce a JPEG image that can be seen immediately on the small LCD screen on the back of the camera and that can be uploaded directly into your computer without the need for any digital processing. Once the images are in your computer, they can viewed immediately.

Some high-end digital cameras render a very high-resolution "RAW" file format that must be digitally processed using special software that comes with the camera when you purchase it. In other words, these files need to be given processing instructions by an imaging software program.

One example is the Canon EOS-1Ds Mark II. This camera creates a CRW file (Canon's version of the RAW file) which must be processed using Canon imaging software. However, the camera also produces low-resolution JPEG images, so you can decide which ones you want to ultimately process with the high-resolution software. The program

will do the processing for you, and the result will be the finest digital images you can get.

Imaging Software

There are a variety of imaging software programs on the market today. Some, such as Apple's iPhoto, come as a standard feature on certain computers, while others must be purchased separately and installed. Programs such as Adobe Photoshop CS (Creative Suite), Photoshop Elements, Photo Impact, and Photo Suite will all perform many of the same tasks. Photoshop Creative Suite is the industry leader and provides the most comprehensive technology on the market.

Any of these programs will enable you to enhance and change your images in an amazing variety of ways; they will also make it possible to correct many problems with the original photo. The most common functions of these programs are as follows:

- To adjust the color of the image
- To adjust the exposure
- To crop and resize your images in a variety of ways
- To remove unwanted "red eye"
- To sharpen the overall image or change the contrast in several ways
- To add frames and borders to a photo before you print it

- To superimpose one photo onto another
- To create a collage of several photos, putting each into its own frame on a single page
- To catalog and store your photos
- With the appropriate photographic scanner, to upload a slide or print and then manipulate it with the same imaging software and then print it.
- To create greeting cards, calendars, posters, business cards, and business advertisements

Digital photography and computer software programs enable you to troubleshoot your own photos. For example, you can correct problems with exposure, red eye, and color. You become your own photo editor and photo doctor. The more you use these programs, the more proficient you'll become at manipulating the images to your liking.

Tricks of the Trade

Anything you create with your imaging software can be printed. You can even get special photo paper with various finishes, heavier stock for cards, and specially sized paper for smaller items such as business cards.

With the more high-end programs, such as the Adobe Photoshop CS, there is virtually no limit to the number of ways you can change, alter, or manipulate your digital images. Not only are these programs extremely helpful in improving the quality of your photos, but they also give you the opportunity to be creative and have fun at the same time.

The Least You Need to Know

- You can have regular film processed at any number of places, from a one-hour photo service to a photo lab.

- You have the option of having prints made of your slides, though the slides will probably have to be sent to a specialty processing lab.

- Some high-end digital cameras come with computer software programs that process the high-resolution digital images.

- Computer software photo programs enable you to creatively manipulate your photo in a variety of ways, as well as correct a number of problems.

Glossary

ambient lighting The natural lighting surrounding a potential photographic subject.

angle In photography, the direction from which a photo is taken. By changing the angle you get a different look.

aperture A diaphragm that opens and closes when you snap the shutter and regulates the amount of light reaching the film plane. The aperture setting regulates the size of the opening.

ASA number A speed rating for a film, based on its sensitivity to light. The ASA will determine how long the shutter stays open depending upon the amount of light necessary for that particular speed of film. The letters stand for American Standards Association.

backlighting A term used to describe the creation of light in the background or from the back of a photo to add depth.

basic composition The way in which a photographer prepares to take a photo and decides what he or she wants to capture on film in that particular shot.

bounce lighting Flash that is aimed at the ceiling or at a wall with the intention of flooding the frame with a reflected blanket of light that has a softening effect.

built-in flash A flash unit permanently built into a camera that will fire on command or when the camera is set to automatic and the lighting conditions call for it.

cable release A cable that attaches to the shutter and enables the photographer to stand away from his or her camera and still snap the shutter. Cable releases come in a variety of lengths.

candid photo Photos taken of people as they are without asking for a formal pose.

centerweight meter A light meter setting that reads a larger area of the frame than that of the spot meter.

color-correcting filter Filter that alters the color within the frame of a photo.

color palette The range of colors that appear in a photograph.

contrast The differentiation between the highlights and shadows in a frame. It is contrast that creates separation between the subject and its surroundings.

depth of field The sharply focused area within a frame. By changing your settings you can have a shallower depth or a deeper one.

digital camera A camera that records a digital image within a file on a media card. Digital cameras do not use film.

disposable camera (throwaway) An inexpensive camera that comes preloaded with a roll of film. Once you shoot the film you take the entire camera to the processing center. The camera is not returned to you.

dog-nose effect An effect in which a subject's head appears distorted, often characterized by the nose appearing very wide. It's the result of an extreme close-up photograph of a subject taken with a wide-angle or extreme wide-angle lens not capable of a close shot.

enhancement filter A filter that enhances the overall look of a photo by color or special effects.

fill flash Flash used to fill in the light on a subject and eliminate hard shadows caused by the primary light.

filter Accessories that cover the lens in order to alter lighting conditions, color scheme, and the amount of light that penetrates to the film.

fish-eye lens A specialty lens, commonly 15mm or 16mm in focal length with a field of vision of roughly 240 degrees. This lens bends the horizontal line in a circular fashion and gives the effect of looking into a fishbowl.

fixed lens A lens on a point-and-shoot camera that cannot be removed and replaced with a different kind of lens.

flash unit An accessory that can be attached to a camera and provides the ability to fire a flash in certain photographic situations. Some cameras have the flash unit built in.

focal length The length of focus of a lens, measured in millimeters (mm).

f-stop A measurement of the amount of light reaching the film. The smaller the f-stop setting, the greater the amount of light allowed in.

frame The total subject area of an individual photo.

halo lighting Light created by a remote flash set up above or behind a subject to effectively separate hair from a background. Also called rim lighting.

imaging software Computer programs that enable you to enhance, alter, crop, troubleshoot, and print your digital photos. There are also programs that will process certain digital images.

Kodak C-41 The name given to the chemical process for developing most color negative films.

lens The glass optic attachment on the front of the camera that redirects and shapes the rays of light that reach the film.

lens hood A lens attachment that shades the lens from letting in unwanted light.

light meter A device that measures the amount of light in any given area and in the area of your frame. Light meters, which can be handheld or built into the camera, help you dial in the correct settings for your photo.

megapixel The word *pixel* is a hybrid of "picture element," which is a colored square that ultimately forms the digital picture. A megapixel is one million pixels.

memory card The name given to the media that records images in digital cameras. Images can be uploaded from the media card into your computer and the cards can be used over and over again.

multiple exposure A technique in which several photos are taken within the same frame while the camera does not advance the film as you press the shutter.

negative space Space within the frame of a photo that is virtually empty. The creative use of negative space can enhance a photograph.

neutral-density filter A filter that cuts down the amount of light allowed to penetrate to the film but does not alter the color of the photograph.

overall meter The overall feature of a built-in light meter gives a light reading for the entire frame, side to side, top to bottom.

panning The act of moving the camera to follow a moving subject, usually done when shooting a sequence of action photos.

panoramic camera or feature A panoramic camera takes extreme wide-angle photos with limited vertical perspective. The panoramic feature on a camera will crop the vertical lines on the top and bottom to enhance the wide-angle view.

point-and-shoot camera A fixed lens camera with limited ability to change settings.

polarizing filter A filter that cuts down on the glare from glass, water, or other shiny surfaces.

portrait A photograph of a person or persons, taken in either formal or informal settings.

power winder A device that is built in or added to a camera that advances the film automatically.

processing The term given to the chemical conversion of film into a final image of negatives, prints, and transparencies, and also to some high-end software imaging programs that process digital photos within a computer.

red eye The reflection from a flash that makes the eyes of a subject glow with a red hue.

rule of thirds A general rule that many photographers use when composing a frame. They break the frame down into three separate elements, either vertically or horizontally.

Scala film A special film that produces black-and-white slides or transparencies.

self-timer A device built into a camera that delays the shutter from being released for a pre-determined amount of time. This can allow the photographer to hop in and become part of the photograph.

sequences A group of photos taken in rapid succession of an action event, showing all phases of the event from start to finish. Often used when photographing sports action.

shutter curtain The counterpart to the aperture, which also controls the amount of light striking the film.

shutter release The button or lever that is depressed to open the shutter and take a photo-graph.

SLR A single-lens reflex camera, usually in the 35mm format.

spot lighting A technique in which a remote flash is positioned to light a particular area of the frame.

spot meter A setting on a built-in light meter that will read the light in specific areas of the frame only.

sync cord An electronic attachment that allows a remote flash to fire at the same time the shutter is depressed.

telephoto lens A lens that brings the subject closer to the camera than it actually is. Telephoto lenses are available in varying focal lengths.

top lighting Any lighting technique that adds light to the top of the frame. It can be from both the sun and an artificial source.

transparency The correct name for a positive image delivered in a cardboard or plastic sleeve, commonly called a slide.

tripod A popular portable and adjustable accessory that stands on three legs and holds a mounted camera in place. It is used for portraits and longer exposures in which the camera must be held very steadily.

tungsten film A film that is specifically balanced for use in indoor artificial lighting conditions.

zoom lens A lens that has a variety of focal length settings. A good zoom lens can take the place of several varying focal length lenses.

Index

...j pictures with the help of *The Complete Idiot's Guides®*

| *The Complete Idiot's Guide®* to Digital Photography, Third Edition 0-02-864453-0 $19.95 | *The Complete Idiot's Guide®* to Photography Like a Pro, Third Edition 1-59257-356-8 $19.95 |

ALPHA